VISUAL QUICKSTART GUIDE

ADOBE
PHOTOSHOP ALBUM 2

FOR WINDOWS

Nolan Hester

 Peachpit Press

Visual QuickStart Guide
Adobe Photoshop Album 2 for Windows
Nolan Hester

Peachpit Press

1249 Eighth Street
Berkeley, CA 94710
(800) 283-9444
(510) 524-2178
(510) 524-2221

Find us on the World Wide Web at: www.peachpit.com

To report errors, please send a note to errata@peachpit.com and psalbum@waywest.net

Peachpit Press is a division of Pearson Education

Copyright © 2004 by Nolan Hester

Editor: Nancy Davis
Production Coordinator: David Van Ness
Composition: David Van Ness
Cover Design: The Visual Group
Cover Production: George Mattingly / GMD
Indexer: Emily Glossbrenner

ISBN: 0-321-24666-7

0 9 8 7 6 5 4 3 2 1

Printed and bound in the United States of America

To Mary, who brings color to my digital and analog worlds.

Special thanks to:

This marks my 12th book for Peachpit Press and it would not have been possible without the help and counsel of two wonderful colleagues: Nancy Davis, my long-standing editor of passion and precision; and David Van Ness, the layout and production genius who keeps transforming my words and pictures into honest-to-goodness books. I look forward to working with them on the next 12 books.

As always, Emily Glossbrenner crafted the wonderfully detailed index, upon which a book's ultimate usefulness rests. Peachpit's publisher, Nancy Aldrich-Ruenzel, continues to make this life of at-home work possible, and my life's the richer for it. Home wouldn't be home, of course, without Laika, who knows that those daily walks keep us both going.

Finally, my thanks to the friends who so kindly let me use their wonderful photos: Amy and Kelly Oliver, Ray Montoya, and Bruce Hammel. My heart-felt appreciation also goes to everyone who appears in these photos: Ellen Diethelm, Linda and Victor Gavenda, the entire Engel clan, Dorothy and Gene Tripp, Jim Brandi, Lenora Olson, Joshua, Jacob, Benjamin, Matthew, Maya, and Soli, plus the beautiful countryside of Spain where I recharged my spirits.

CONTENTS AT A GLANCE

	Introduction	xi
Chapter 1:	Getting Photos	1
Chapter 2:	Viewing and Organizing Photos	23
Chapter 3:	Working with Catalogs	61
Chapter 4:	Finding Photos	73
Chapter 5:	Editing Photos	87
Chapter 6:	Creating Projects	107
Chapter 7:	Sharing Photos	131
	Index	161

TABLE OF CONTENTS

Introduction **xi**

What's New . xii

Hardware and Software Requirements xii

Installing and Starting Photoshop Album xiii

Photoshop Album Basics. xvi

The Quick Guide. xvi

The Main Window . xvii

The Toolbars and Timeline. xviii

Photoshop Album Views. xix

Switching Views . xix

Navigating the View History xx

Photoshop Album Modes . xxi

Using this Book. xxiv

Updates and Feedback . xxvi

Chapter 1: Getting Photos **1**

Setting Up Photo Importing. 2

Setting Camera or Card Reader
Import Preferences . 2

Importing Photos from Camera or Card Reader. . . 3

Importing Directly from a Digital Camera 4

Importing from a Card Reader 7

Importing from a Scanner. 8

Setting Scanner Preferences. 8

A Tale of Two Formats . 8

Importing Photos from a Scanner 9

Importing Files from Your Computer. 10

Importing Specific Photos . 10

Searching Your Computer for Photos. 12

Rights and Copyrights . 13

Importing Photos from PhotoDeluxe or
ActiveShare Albums . 14

Importing Photos from a CD or DVD. 15

Importing Photos from a Mobile Camera Phone . 18

Setting Mobile Camera Phone Preferences 19

Deleting Photos . 21

Chapter 2: Viewing and Organizing Photos 23

Working with Photos . 24
Changing Photo Sizes in the Photo Well 24
Rearranging the Photo Well View 25
Viewing an Instant Slideshow 27
Playing Video Clips . 28
Viewing, Adding or Changing Photo Details 29
Showing or Hiding the Properties Window 30
Adding Captions . 31
Removing Captions . 32
Adding Notes . 32
Adding Audio Captions . 33
Removing Audio Captions . 34
Renaming Photos . 35
Changing a Photo's Date or Time 36
Working with Date and Time Changes 37
Working with Tags . 38
Showing or Hiding the Tags Pane 38
Changing the Tags Pane View 39
Creating a New Tag . 40
Attaching Tags to a Single Photo 41
Attaching Tags to Multiple Photos 42
Attaching a Tag to an Import Batch or Folder . . . 43
Creating Tags Using Folder Names 44
Removing Tags from Photos 45
Organizing Tags . 46
Creating a New Tag Category 46
Creating a New Tag Sub-category 47
Changing a Tag's Category, Name, or Note 48
Changing a Tag Icon's Appearance 49
Reassigning Tags to Another Category or
 Sub-category . 51
Reassigning Tags by Dragging and Dropping 52
Expanding or Collapsing the Tags View 53
Deleting a Tag . 54
Working with Collections . 55
Showing the Collections Pane 55
Creating a Collections . 56
Removing Photos from a Collection 58
Removing a Collection . 58
Rearranging Photos in a Collection 59
Changing a Collection Name, Note, or Icon 60

Chapter 3: **Working with Catalogs** **61**

Backing Up Catalogs. 62
Recovering and Restoring Catalogs 67
Recovering a Catalog . 67
Restoring a Catalog. 68
Making, Switching, or Copying Catalogs. 70
Creating a New Catalog. 70
Switching Catalogs . 71
Copying a Catalog . 71

Chapter 4: **Finding Photos** **73**

Finding Photos Using Tags. 74
Cancelling a Find . 75
Finding Photos Using Multiple Tags. 76
Searching With the Favorites and Hidden Tags . . 76
Understanding Multiple-Tag Searches. 77
Finding Photos by Date . 78
Finding Photos with the Timeline 78
Finding Tagged Photos with the Timeline 79
Finding Photos with the Calendar View 80
Finding Photos with Unknown Dates 82
Other Ways of Finding Photos 83
Finding Photos by Filename 83
Finding Photos by Caption or Note. 83
Finding Photos by History . 84
Finding Photos by Media Type 85
Finding Photos of Similar Color 85

Chapter 5: **Editing Photos** **87**

Selecting, Rotating Photos . 88
Using the Fix Photo Dialog Box 89
Undoing and Redoing Photos 91
Cropping Photos . 92
Removing Red Eye. 93
Changing Photos to Black-and-White or Sepia. . . 94
Calibrating Your Monitor . 95
Fixing Photos Automatically. 97
Automatically Fixing Single Photos 97
Automatically Fixing Multiple Photos. 99
Manually Adjusting Photos 100
Manually Adjusting Highlights and Shadows. . . 100
Manually Adjusting Color 101
Using Other Photo Edit Programs. 102
Changing the Default External Photo Program . 103
Editing with Another Photo Program 104

TABLE OF CONTENTS

Chapter 6: **Creating Projects** **107**

Using the Creations Wizard 108
Creating a Photo Album . 114
Creating Slideshows . 116
Creating a Slideshow on a Video CD 118
Creating Greeting Cards and eCards 119
Creating a Greeting Card . 119
Creating an eCard . 121
Creating Photo Calendars. 124
Creating a Bound Photo Book 126
Finding Saved Projects . 128
Opening Saved Projects. 129

Chapter 7: **Sharing Photos** **131**

How Big is Big Enough?. 131
Using Photos on Your Desktop. 133
Setting Up Online Photo Services 134
Emailing Photos and Projects. 136
Setting Email Preferences. 137
Opening the Contact Book 138
Adding Contacts to the Contact Book 138
Adding Groups to the Contact Book 139
Changing or Deleting Contacts and Groups 139
Emailing Photos. 140
Emailing Projects . 143
Sharing Photos with Phones and PDAs. 144
Sharing Photos with a Mobile Camera Phone. . . 145
Sharing Photos with a Handheld PDA. 146
Sharing Photos Using a Web Site. 147
Sharing Photos on a CD or DVD 150
Burning a Project to a CD or DVD 151
Burning Individual Photos to CD or DVD 152
Exporting Photos. 154
Printing Photos . 155
Setting Your Printer Options. 155
Printing Photos on Your Own Printer 156
Ordering Prints Online . 158
Ordering a Bound Photo Book Online. 160

Index **161**

INTRODUCTION

Digital photography is fun. You click a button and the results appear on the camera screen almost instantly. Digital photography also can be frustrating. Anyone with a digital camera will instantly recognize this scene. Buried *somewhere* amid hundreds of computer files with names like 101-0144_IMG_2.JPG and 104-0459_STE.JPG are your pictures of Aunt Mutt and Uncle Leo at the Grand Canyon. Getting the pictures into the computer was easy. In fact, getting Uncle Leo to smile was a snap compared to trying to find that picture of him on your computer.

Relax. Adobe Photoshop Album makes such hair-pulling searches a thing of the past. Not only will Photoshop Album easily find your photos, it also will inspire and guide you in creating online galleries, electronic greeting cards, and even printed albums. Instead of leaving your photos hidden in a shoebox, you'll be able to easily add them to email, store them as CD-based slideshows, or even order extra prints online that will make Uncle Leo grin all over again.

This book will help you master all the exciting options in Photoshop Album. It also will offer plenty of ideas and tips on how to organize, edit, and share your photos.

What's New

If you are upgrading from the original Photoshop Album, you'll find that version 2.0 has been tweaked in all the right places. Aside from the Tags pane having shifted from the left to the right side of the screen, the most obvious change is the new slider bar that lets you smoothly zoom in or out to view individual or groups of photos. In addition to using tags, you now can create what Adobe calls "collections" of photos, which act as customized views of your photos. For more information, see *Working with Collections* on page 55. Photoshop Album also now can work with photos taken with a mobile phone or PDA, and even display them using a TiVo Digital Video Recorder. For more information, see *Getting Photos* on page 18 and *Sharing Photos* on page 131.

Hardware and Software Requirements

Anyone with a computer made in the past three or four years should have no problem running Photoshop Album.

To run Photoshop Album, you need:

◆ A Windows computer running a Pentium III or faster processor chip with at least 128MB of RAM. (256MB is even better.)

◆ Your computer also needs a USB port, which will let you connect your digital camera or a photo-card reader.

◆ A hard drive with at least 250MB of free space for installing Photoshop Album. Digital photos themselves can eat up a lot of space, though any computer sold in the past three or four years is likely to have plenty of space.

◆ A color monitor with at least a resolution of 800 x 600 and 256 colors.

◆ A CD or DVD drive for installing the Photoshop Album program.

◆ Microsoft Windows 2000, Me, or XP, plus Microsoft Internet Explorer 5.01 (with Service Pack 2), 6.0 or above.

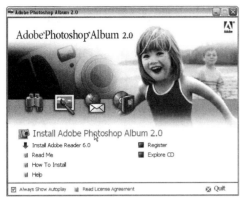

Figure i.1 When the installation screen appears, click *Install Adobe Photoshop Album 2.0.*

Installing and Starting Photoshop Album

Like Photoshop Album itself, installing the program is fairly straightforward. Before you start, however, be sure to check the hardware and software requirements listed on the preceding page.

To install Photoshop Album:

1. Exit any other programs you may be running and insert the Photoshop Album CD into your CD or DVD drive.

2. Once the CD launches and the Adobe Welcome screen appears, choose your preferred language, and click *Accept* when the License Agreement appears.

3. When the installation window appears, click *Install Adobe Photoshop Album* 2.0 (**Figure i.1**). The InstallShield Wizard will launch and prepare to install the program. Click *Next* as the prompts appear.

4. When the Adobe Photoshop Album 2.0 Setup dialog box appears, fill in your personal information and serial number, then click *Next*. (You'll find the serial number on the inside of the CD case.)

(continued on next page)

INSTALLING AND STARTING PHOTOSHOP ALBUM

5. If you are upgrading from version 1.0, a dialog box will appear asking whether you want to uninstall the earlier version before installing version 2.0. Click *Yes*. Even if you want to have both versions of the program on your computer, the installer requires that you remove the earlier version and then reinstall it after version 2.0 has been installed. Whether you are upgrading or installing Adobe Photoshop Album for the first time, by default, the installer offers to install the program at C:\Program Files\Adobe\Photoshop Album 2.0. If you want to install the program elsewhere, click *Browse* and navigate to your preferred folder. Once you've picked a destination folder, click *Next* (**Figure i.2**).

6. If you are upgrading from version 1.0, the earlier version will be uninstalled before the version 2.0 installation begins (**Figure i.3**). Any photos and catalogs created with the earlier version, however, will remain entirely safe.

7. The last installation dialog box gives you the choice of seeing the Readme file, which highlights details about running the program, and launching Photoshop Album itself. Make your choices and click *Finish* (**Figure i.4**). If you chose to start the program, the Photoshop Album startup screen will appear (**Figure i.5**), followed by the program's Quick Guide and main window. The next section, *Photoshop Album Basics*, explains the Quick Guide, main window, and major toolbars.

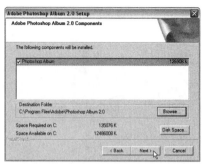

Figure i.2 By default, the program is installed at C:\Program Files\Adobe\Photoshop Album 2.0. Click *Browse* if you want to install it somewhere else.

Figure i.3 If you are upgrading from version 1.0, the earlier will be uninstalled before the version 2.0 installation begins.

Figure i.4 Almost done: Check the boxes to make your choices and click *Finish*.

Figure i.5 When you start the program, the Photoshop Album startup screen will appear.

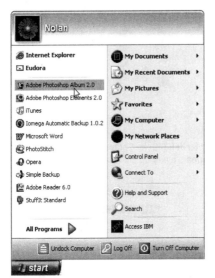

Figure i.6 To launch the program, double-click the shortcut icon on your desktop (top) or use the Start menu to choose All Programs\Adobe Photoshop Album 2.0 (bottom).

To start Photoshop Album:

◆ Double-click the Adobe Photoshop Album shortcut icon on your desktop (top, **Figure i.6**) or use the Start menu to choose All Programs\Adobe Photoshop Album 2.0 (bottom, **Figure i.6**). By default, the Photoshop Album Quick Guide appears every time you launch the program; use it to start a task by clicking its icons and tabs. (See the *To turn the Quick Guide off or on* section on the next page if you want to work directly in the Photoshop Album main window.)

✔ Tip

■ If you are upgrading from version 1, Photoshop Album will ask you to navigate to that version's catalog, which it will then convert to the version 2 format.

Photoshop Album Basics

Before you begin using the program, let's take a look at its main components. For more information on various aspects of the program, see the pages listed in each section.

The Quick Guide

By default, the Quick Guide appears every time you launch Photoshop Album. The guide's *Overview* tab (**Figure i.7**) invites you to click any one of six icons or matching tabs to perform common tasks. The icons and tabs correspond to Photoshop Album's six modes, which are explained later in the Introduction on page xxi.

To turn the Quick Guide off or on

◆ Choose Edit > Preferences (⟨Ctrl⟩⟨K⟩) and when the Preferences dialog box appears, uncheck *Show Quick Guide at Startup* (**Figure i.8**). Click *OK* to close the dialog box and if the Quick Guide was visible, it will now disappear; if it was hidden, it will appear.

To hide the Quick Guide by default

◆ When the Quick Guide appears after starting Photoshop Album, uncheck the box in the lower-left corner (**Figure i.9**). The next time you launch Photoshop Album, the Quick Guide will be hidden by default.

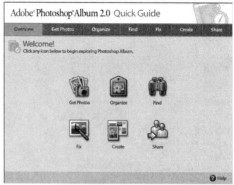

Figure i.7 By default, the Photoshop Album Quick Guide appears every time you launch the program.

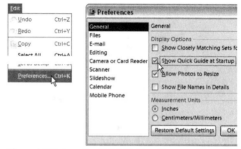

Figure i.8 To turn the Quick Guide off or on, choose Edit > Preferences (⟨Ctrl⟩⟨K⟩) (left) and when the Preferences dialog box appears, uncheck *Show Quick Guide at Startup* (right).

Figure i.9 Uncheck the box in the Quick Guide's lower-left corner if you do not want it to appear every time you launch Photoshop Album.

The Main Window

The Photo Well dominates the program's main window (**Figure i.10**). Using the slider in the bottom Options bar, you can change the Photo Well view from tiny thumbnails of many photos to just a single large photo. Use the right-side Tags pane to organize and classify your photos using keywords. Photoshop Album makes it easy to customize the main window to show only what you need, when you need it. For more information about the Photo Well, see *Photoshop Album Views* on page xix.

Menu bar

Shortcuts bar
(next page)

Timeline
(page 78)

Find bar with
search criteria
and results
(page 73)

Photo's date
& time

Photo Well

Tag categories
applied to this
photo

Tag's
sub-category
appears with
cursor roll-over

Options bar
(next page)

View tabs
(page xix)

Tab for
Collections
pane (page 55)

Tags pane
(page 38)

Tag tools
(page 38)

Tag categories
(page 46)

Sub-categories
for People tag

Search for tag
(Amy, Kelly &
kids)

Creations clip
(page 107)

Video clip
(page 28)

Selected photo;
Double-click to
view full size

Status bar

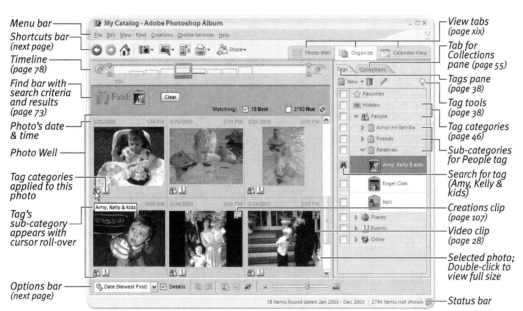

Figure i.10 The Photo Well, with its slider for zooming in or out to see photos, dominates the program's main window.

THE MAIN WINDOW

The Toolbars and Timeline

Using the Menu bar, Shortcuts bar, and the related timeline, you can perform most of Photoshop Album's major tasks. By clicking the icons in the Shortcuts bar (**Figure i.11**), you often can avoid hunting through the Menu bar's drop-down menus. Right below the Shortcuts bar lies the timeline, which you use to zero in on the photos you're seeking. Depending on how much information you need at the moment, the Options bar across the bottom of the main window can show or hide various views of the Photo Well (**Figure i.12**). For more information on the Find bar, see page 73.

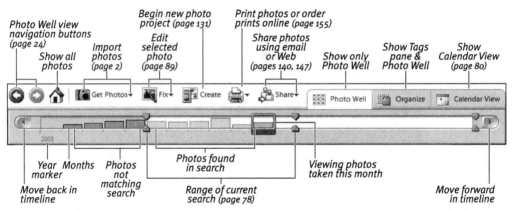

Figure i.11 The Shortcuts bar (top) provides quick access to all of Photoshop Album's major tasks. The timeline (bottom) helps you quickly find photos.

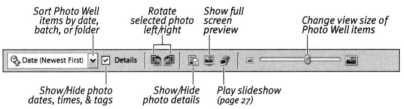

Figure i.12 Use the Options bar to sort the Photo Well, show or hide photo details, rotate selected photos, preview fullscreen versions, play a slideshow, or zoom in or out on photos.

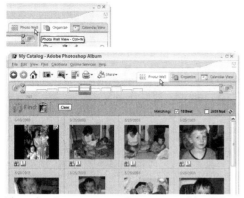

Figure i.13 To see as many photos as possible, click the *Photo Well* tab (top) and the main window will switch to reflect your choice (bottom).

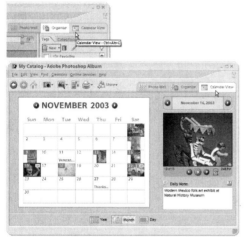

Figure i.14 To find photos shot on a particular date, click the *Calendar View* tab (top) and the main window will switch to a monthly view of your photos (bottom).

Photoshop Album Views

By default, Photoshop Album displays the Photo Well with the Tags pane (**Figure i.10**). To see as many photos as possible, you may want to switch to the Photo Well only view (**Figure i.13**). If you're trying to find photos shot on a particular date, switching to the Calendar View makes that easier (**Figure i.14**). Photoshop Album offers another way to view your photos that takes a minute to explain but is very handy once you understand how it works. In effect, it works much like a Web browser's back and forward buttons, letting you navigate through the viewing history of your photos. By using it, you can, for example, look at some photos at the bottom of the Photo Well, then use the Find function to inspect a particular set of photos, and then use the back button to jump back to your view at the bottom of the Photo Well. It's a great way to compare different sets of photos without having to repeat a previous Find command.

To switch among views:

◆ Click the tab in the upper-right of the main window to switch to the desired view (top, **Figure i.13**). The main window will change to reflect your choice (bottom, **Figure i.13**).

To navigate the view history:

◆ To return to a previous view of your photos click the back button (the one with the arrow pointing to the left) in the Shortcuts bar (**Figure i.15**). The Photo Well will show your previous selection of photos, including previous search results (**Figure i.16**).

◆ To move forward again to another view of your photos click the forward button (the one with the arrow pointing to the right) in the Shortcuts bar (**Figure i.16**). The Photo Well will update to display the next selection of photos.

✔ Tip

■ Your viewing history of the photos is available only for your current work session. If you quit Photoshop Album, the history is not saved.

Figure i.15 Return to a previous view of your photos by clicking the back button in the Shortcuts bar.

Figure i.16 Move forward to another view of your photos by click the forward button in the Shortcuts bar.

PHOTOSHOP ALBUM VIEWS

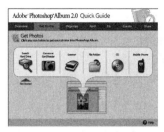

Figure i.17
Click the *Get Photos* tab and the Quick Guide will help you import photos from your camera or other sources.

Figure i.18
Use the *Organize* tab to have the Quick Guide show you how to use tags to organize your photos.

Figure i.19
The Quick Guide's *Find* tab helps you search for photos by tag, calendar view, or by date.

Figure i.20
Use the *Fix* tab to get help correcting common photo problems.

Figure i.21
The *Create* tab in the Quick Guide shows you how to create a variety of photo-based projects.

Photoshop Album Modes

Photoshop Album has six modes, which are built around the basic tasks you'll perform while working with your photos. Photoshop Album automatically switches from mode to mode, depending on which task you are performing. Click the Quick Guide's Get Photos tab, for example, and you're instantly working in the Get Photos mode. You can use the Quick Guide to walk you through any mode (**Figures i.17–22**), or perform a task directly just by choosing a menu command or Shortcuts icon.

Get Photos mode

Use the Get Photos mode to bring photos into Photoshop Album from a variety of image sources: a digital camera or memory card, a scanner, files already on your computer or stored on CDs, or even on a mobile phone. For more information, see *Getting Photos* on page 1.

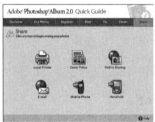

Figure i.22 The *Share* tab in the Quick Guide helps you print photos or order prints from an online service. It also helps you create quick-to-download versions to share over email, mobile phones, or handheld organizers.

Organize mode

Organize mode goes to the heart of what makes Photoshop Album so powerful. By letting you create your own labels, or what it calls tags, Photoshop Album makes it easy to organize your photos in a variety of ways. You can create a general category tag, then break it down into as many sub-categories as needed. And Photoshop Album lets you apply multiple tags to the same photo, which means, for example, that you can apply enough labels to a shot to reflect that it shows your *mom* in the *garden* on the *Fourth of July*. For more information, see *Viewing and Organizing Photos* on page 23.

Find Photos mode

Thanks to the amazing flexibility of the Find Photos mode, it doesn't matter what the file name is for an image. You can find it by searching for the tags you've applied to it or by when it was shot. The Calendar View makes it easy to see how many, and on which days, photos have been imported into Photoshop Album (**Figure i.14**). You can then flip through a day to find a particular photo. Or you can use the timeline to set a range of dates to search (**Figure i.11**). For more information, see *Finding Photos* on page 73.

Fix Photo mode

Even smart digital cameras make mistakes, not to mention the occasional photographer. The Fix Photo mode helps you quickly correct common problems with brightness and contrast, lighting, or red eye triggered by an indoor flash (**Figure i.23**). For more information, see *Editing Photos* on page 87.

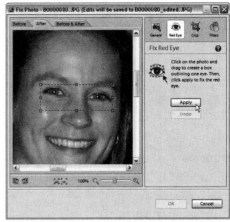

Figure i.23 The Fix Photo mode lets you correct common problems such as flash-related red eye.

PHOTOSHOP ALBUM MODES

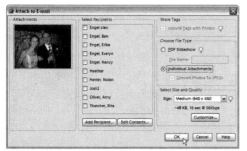

Figure i.24 Photoshop Album not only helps you create email-friendly photos but also tells you how long they will take to download.

Create mode

The Create mode takes your photos to a whole new level by helping you assemble an onscreen slideshow, make a greeting card, or even publish a hardbound photo album. For more information, see *Creating Projects* on page 107.

Share mode

Half the fun of taking photos is sharing them with others. The Share mode makes it easy. For example, it can help you create a quick-to-download version of a photo to send through email (**Figure i.24**). At the same time, it will preserve your bigger original image file for later use in other projects. For more information, see *Emailing Photos* on page 140 and *Sharing Photos* on page 131.

Using this Book

The key to this book, like all of Peachpit's Visual QuickStart Guides, is that word *visual*. As much as possible, I've used illustrations with succinct captions to explain major functions and options in Photoshop Album. Ideally, you should be able to quickly locate what you need by scanning the page tabs, illustrations, and captions. Once you find a relevant topic, the text provides details and tips.

You'll find it easy to work your way through the book chapter by chapter. If you've got an immediate question about Photoshop Album, however, the book makes it easy for you to dive right in and get help quickly.

◆ **Tips:** Signified by a ✔ in the margin, tips highlight shortcuts for performing common tasks or ways you can use your new Photoshop Album skills to solve common problems.

◆ **Italic words:** When *italicized* words appear in the book's text, you'll find the very same words on the Photoshop Album screen itself when you reach that step in the program. The italicized term might appear as a button or tab label, the name of a text window or an option button in a dialog box, or as one of several choices in a drop-down menu. Whatever the context, the italics are meant to help you quickly find the item in what can sometimes be a crowded screen. If the step includes an accompanying illustration, use it to help you find the item being discussed. For example: Click the *Greeting Card* icon and the Workspace dialog box will appear.

USING THIS BOOK

Figure i.25 Sometimes a deep original menu (left) or dialog box will be snipped in the middle (right) to save space on the printed page.

◆ **Code font:** When a word or words appears in code font, it's used to indicate the literal text you need to type into Photoshop Album. For example: In the Find by Filename text window, type `friends` and press (Enter).

◆ **Menu commands and keyboard shortcuts:** Menu-based commands are shown as: Edit > Update Thumbnail, which means click on the Edit menu and then choose Update Thumbnail from the choices that appear. Keyboard-based shortcuts (when available) are shown in parentheses after the first step in which they can be used. For example: ((Ctrl)(R)) means that you should press the (Ctrl) and (R) keys at the same time to rotate a photo to the right.

◆ **Cuts in figures:** Sometimes a Photoshop Album dialog box or menu is so deep that it can be hard to fit on the page with all the other figures and still leave it large enough to read. In those cases, I cut out the middle or end of the figure to save some space, marking it with a blank stripe across the figure (**Figure i.25**). Nothing critical to understanding the step is ever left out. And it sure beats running teeny, tiny figures.

Updates and feedback

For Photoshop Album updates and patches, make a point of checking the Adobe Web site for Photoshop Album from time to time: www.adobe.com/products/photoshopalbum/

This book also has a companion Web site where you'll find examples from the book, and tips and tricks based on real-world tasks. So drop by www.waywest.net/psalbum/ when you can. You're also welcome to write me directly at psalbum@waywest.net with your own tips or—heaven forbid—any mistakes you may have spotted. Your help just might save Uncle Leo from some frustration when he buys his own digital camera—and the next edition of this book.

UPDATES AND FEEDBACK

GETTING PHOTOS

To tap the powers of Photoshop Album, you start by importing your photos into the program. Photoshop Album can handle just about anything: brand-new digital camera shots, images stored on a CD or DVD, scans of prints, and photos from a camera phone. It will even search your hard drive for image files you could never find on your own. One of the beauties of Photoshop Album is that it doesn't force you to actually copy all those non-camera images onto your hard drive. Instead, it creates a thumbnail or "proxy" image within a Photoshop Album catalog, which remembers where the original is stored. By using these proxy images, Photoshop Album is fast and easy to work with. When you edit the proxy image, those changes do not affect the original image, so your files—and memories—remain safe.

Setting Up Photo Importing

Photoshop Album can easily pull photos directly from your camera or a USB-enabled card reader. Once you set the camera or card reader import preference in Photoshop Album, that camera or card reader will be used by default for future photo imports.

To set the camera or card reader import preference:

1. Plug the camera or card reader you'll be using into your computer's USB port, using the USB cable that came with the camera or card reader. If you're using a camera, turn it on after plugging it in.

2. Within Photoshop Album, choose Edit > Preferences (Ctrl K) (**Figure 1.1**).

3. When the Preferences dialog box appears, choose *Camera or Card Reader* in the left-hand list, then click the *Camera* drop-down menu in the right-hand panel (top, **Figure 1.2**).

4. Select your camera or card reader in the drop-down menu (bottom, **Figure 1.2**).

5. In most cases, leave the rest of the preference settings as they are (**Figure 1.3**), or see the *Camera or Card Reader Preferences* sidebar on the next page. Click *OK* to close the Preferences dialog box. You're ready to import camera or card reader photos into Photoshop Album.

Figure 1.1 To set any of the preferences for importing photos, choose Edit > Preferences.

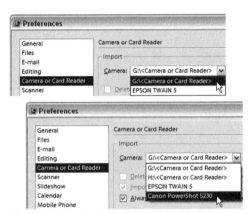

Figure 1.2 When the Preferences dialog box appears, choose *Camera or Card Reader* in the left-hand list (top), then select your camera or card reader in the drop-down menu (bottom).

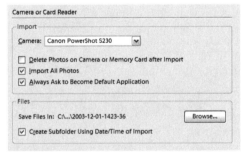

Figure 1.3 For more information on the rest of the preference settings, see the *Camera or Card Reader Preferences* sidebar.

Camera or Card Reader Preferences

Most of the Preferences dialog box's *Camera or Card Reader* settings should be left as you find them (**Figure 1.3**).

◆ **Delete Photos on Camera or Memory Card after Import.** By default, this is not checked, which means the photos will remain on your camera's memory card until you are sure they've been transferred to your computer.

◆ **Import All Photos.** If your camera supports WIA (Windows Image Acquisition) and you're running Windows XP or Windows Me, you'll be able to change the setting.

◆ **Always Ask to Become Default Application.** By default, this is checked and grants Photoshop Album permission to launch automatically whenever you connect a WIA-driven camera to a computer running Windows XP or Windows Me. Photoshop Album must be launched manually on computers running Windows 2000.

◆ **Save Files In.** By default, Photoshop Album stores images in a subfolder at C:\Documents and Settings\YOUR USER NAME\My Pictures\Adobe\Digital Camera Photos\. If you need to store them on a larger hard drive, click *Browse* and navigate to another folder.

◆ **Create Subfolder Using Date/Time of Import.** Checked by default, this option helps keeps the images folder a bit more organized in the rare event that you need to look in it directly.

Importing Photos from a Camera or Card Reader

How photos are imported into Photoshop Album depends on which version of Windows your computer uses. It's not something you need to mess with, however. Just install the software that came with your digital camera, and Photoshop Album will handle the necessary negotiations behind the scenes. In general, computers running Windows XP or Windows Me will use one type of software device driver (Windows Image Acquisition) for your camera, which will then automatically launch Photoshop Album whenever you connect your camera to the computer. Computers running Windows 2000 will install another type of device driver (TWAIN), which will require you to manually launch Photoshop Album.

Instead of importing photos directly from your camera, consider buying a memory card reader. Available for all the major memory card formats, such readers cost as little as $20 and offer several advantages over a camera-to-computer connection. Card readers, for example, do not need special software drivers to work. Plug the reader into your USB port and you're set. They also offer a shorter importing process similar to that used on Windows XP or Me computers—even if your computer's running Windows 2000. Using a card reader also saves your camera batteries. Digital cameras must be turned on for importing and many camera manufacturers do not include a power cord, except as an expensive add-on. By using a card reader, you can save the camera's batteries for taking pictures.

(continued on next page)

To import photos directly from a camera:

1. Connect your camera to a USB cable and turn the camera on. If you're running Windows XP or Me, Photoshop Album will launch automatically and begin the import process, so skip to step 7. If you're running Windows 2000, start Photoshop Album manually.

2. Click the Quick Guide's *Get Photos* icon or tab and then click the *Camera or Card Reader* icon when it appears (**Figure 1.4**).

 or

 In the Shortcuts bar, choose Get Photos > From Camera or Card Reader ($\boxed{Ctrl}\boxed{G}$) (top, **Figure 1.5**).

 or

 From the Menu bar, choose File > Get Photos > From Camera or Card Reader ($\boxed{Ctrl}\boxed{G}$) (bottom, **Figure 1.5**).

3. If you set your camera as the default in *Setting Up Photo Importing* on page 2, it will be listed automatically in the *Camera or Card Reader* portion of the Preferences dialog box (**Figure 1.3**). If it's set for your card reader, use the *Camera* drop-down menu to choose your camera. Once you've made your choice, click *OK* to close the dialog box.

4. When the TWAIN dialog box appears, choose File > Connect to Camera (**Figure 1.6**). (The name of the dialog box will vary depending on your camera's driver.)

Figure 1.4 Use the Quick Guide to import photos from a camera by clicking the *Camera or Card Reader* icon under the *Get Photos* tab.

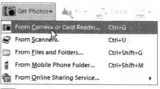

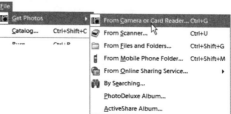

Figure 1.5 You also can import photos by using the Shortcuts bar to choose Get Photos > From Camera or Card Reader (top) or choose File > Get Photos > From Camera or Card Reader (bottom) ($\boxed{Ctrl}\boxed{G}$).

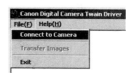

Figure 1.6 If you're running Windows 2000, Photoshop Album will launch the TWAIN dialog box. Choose File > Connect to Camera.

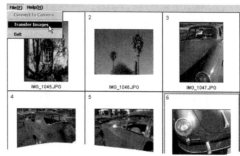

Figure 1.7 Click to select the photo you want to import (\boxed{Shift}-click to select more than one photo), and choose File > Transfer Images.

Figure 1.8 The Transfer Images dialog box tracks the transfer of the photos and then closes automatically.

Figure 1.9 Close the TWAIN driver dialog box by choosing File > Exit.

5. When your photos appear in the TWAIN dialog box, click to select the photo you want to import (Shift-click to select more than one photo), and choose File > Transfer Images (**Figure 1.7**). The Transfer Images dialog box displays a status bar that tracks the transfer of the photos (**Figure 1.8**), and then closes automatically when done.

6. Now close the TWAIN driver dialog box by choosing File > Exit (**Figure 1.9**).

7. The Getting Photos dialog box will appear with a status bar tracking the importing of the photos (**Figure 1.10**). Once the import is done, the dialog box will close automatically and an alert dialog box will remind you that Photoshop Album will display only the newly imported photos (**Figure 1.11**).

(continued on next page)

Figure 1.10 A status bar tracks the import of your photos into Photoshop Album.

Figure 1.11 If you don't want to see this reminder after every import, select *Don't Show Again* and click *OK*.

IMPORTING PHOTOS FROM A CAMERA

8. Click *OK* to close the alert dialog box (see the first *Tip* below) and Photoshop Album will display the newly imported photos in the Photo Well (**Figure 1.12**). You now can work with your new photos within Photoshop Album.

✔ Tips

- After you read the alert dialog box that appears in step 7 (**Figure 1.11**), you probably don't need to see it again. Select the *Don't Show Again* checkbox before clicking *OK* and it will not reappear with each import.

- If you forget to turn off your camera after importing photos, a reminder dialog box will appear (**Figure 1.13**). You can always click *Yes*, but your battery won't last as long.

- To see all your photos, instead of just the new imports, click the Show All icon in the Shortcuts bar or press the Spacebar.

- If you've already imported a photo, Photoshop Album will skip that photo during the current import session and alert you that it already exists in its catalog (**Figure 1.14**).

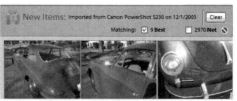

Figure 1.12 The newly imported photos will appear in the Photo Well where you can begin working with them.

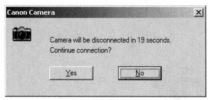

Figure 1.13 To save its battery, your camera will ask if you want to leave it on.

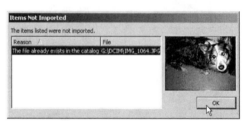

Figure 1.14 If you've already imported a photo, Photoshop Album will skip importing it and note that it already exists in the catalog.

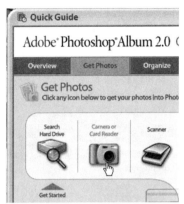

Figure 1.15 Use the Quick Guide to import photos from a card reader by clicking the *Camera or Card Reader* icon under the *Get Photos* tab.

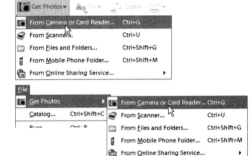

Figure 1.16 You also can import photos by using the Shortcuts bar to choose Get Photos > From Camera or Card Reader (top) or choose File > Get Photos > From Camera or Card Reader (bottom) (Ctrl G).

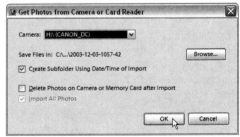

Figure 1.17 Make sure your card reader is selected in the *Camera* drop-down menu, then click *OK*.

To import photos from a card reader:

1. Connect your card reader to your computer's USB port or hub. The computer doesn't need to be turned off to do this. You only have to do this once since the reader can be left connected to the computer without interfering with other operations.

2. Start Photoshop Album. Click the Quick Guide's *Get Photos* icon or tab and then click the *Camera or Card Reader* icon when it appears (**Figure 1.15**).
 or
 In the Shortcuts bar, choose Get Photos > From Camera or Card Reader (top, **Figure 1.16**).
 or
 From the Menu bar, choose File > Get Photos > From Camera or Card Reader ((Ctrl G)) (bottom, **Figure 1.16**).

3. When the Get Photos from Camera or Card Reader dialog box appears, make sure your card reader is selected in the *Camera* drop-down menu, then click *OK* (**Figure 1.17**).

4. The Getting Photos dialog box will appear with a status bar that tracks the photos being imported. Once the import is done, the dialog box will close automatically and an alert dialog box will remind you that Photoshop Album will display only the newly imported photos.

5. Click *OK* to close the alert dialog box and Photoshop Album will display the newly imported photos in the Photo Well.

✔ Tip

- Of the three options for importing, the Shortcuts bar icon is the most direct.

Importing from a Scanner

Photoshop Album can import images directly from a scanner—if it's connected to a USB port (and assuming you've installed all the software that came with your scanner). If you have an older scanner with a SCSI (Small Computer System Interface) connection, use the scanner to save the image to your hard drive and then import it into Photoshop Album following *Importing Files from Your Computer* on page 10. If you prefer to use the scanning program that came with your scanner, you can still bring the photos into Photoshop Album by following *Importing Files from Your Computer* on page 10.

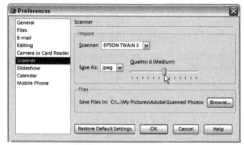

Figure 1.18 Use the Preferences dialog box to set your default scanner preferences.

Figure 1.19 If you expect to crop the scanned photo by very much, change the setting to *Quality: 12 (Maximum)*.

To set scanning preferences:

1. Connect your scanner to your computer's USB port or hub and turn on the scanner. The computer doesn't need to be turned off to do this.

2. Start Photoshop Album and choose Edit > Preferences. When the Preferences dialog box appears, select *Scanner* in the left-hand pane (**Figure 1.18**). Photoshop Album should automatically list your scanner in the Scanner text field. If it does not, use the drop-down menu to find it in the list.

3. By default, Photoshop Album will save your scanner files as a *jpeg* file set to *Quality: 6 (Medium)*. If you expect to crop the photo by very much, however, you should change the setting to *Quality: 12 (Maximum)* (**Figure 1.19**). While your files will be larger—and take a bit longer to scan in—you will have more options when editing the photos and creating projects.

4. Once you've made your choices, click *OK* to close the Preferences dialog box. You're ready to start scanning.

A Tale of Two Formats

The JPEG format is superb for creating compact photo files that transmit quickly over email or the Web. But the drawback is that the JPEG format throws away data when it saves a photo. In fact, a JPEG image loses data *every* time you save it. If you repeatedly change, and then again save, a JPEG photo, its quality will decline a tiny bit with every save. In contrast, the TIFF format does not remove data, but it takes more storage space. If you expect to do a lot of editing on an image, import it as a TIFF file, make all your changes, and if you then want to send out an email or Web version, Photoshop Album can automatically convert it to the JPEG format.

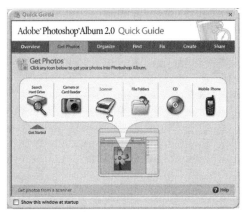

Figure 1.20 Use the Quick Guide to import photos from a scanner by clicking the *Scanner* icon under the *Get Photos* tab.

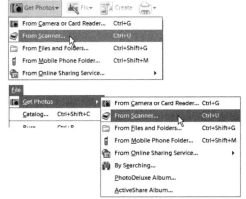

Figure 1.21 You also can import photos by using the Shortcuts bar to choose Get Photos > From Scanner (top) or using the Menu bar to choose File > Get Photos > From Scanner (bottom) (⌨Ctrl U).

Figure 1.22 The newly scanned photos appear in the Photo Well.

To import photos from a scanner:

1. Connect your scanner to your computer's USB port or hub and turn on the scanner. The computer doesn't need to be turned off to do this. If you haven't already set the scanning preferences for Photoshop Album, see the previous page.

2. Click the Quick Guide's *Get Photos* icon or tab and then click the *Scanner* icon when it appears (**Figure 1.20**).

 or

 In the Shortcuts bar, choose Get Photos > From Scanner (⌨Ctrl U) (top, **Figure 1.21**).

 or

 From the Menu bar, choose File > Get Photos > From Scanner (⌨Ctrl U) (bottom, **Figure 1.21**).

3. If your computer is running Windows XP or Windows Me, skip to step 4. If it's running Windows 2000, a dialog box for your scanner's TWAIN driver will appear and prepare to scan. Depending on your scanner (and whether you're scanning a print, film, or a slide), this may involve several steps and a series of automatically launching dialog boxes.

4. Depending on the size or number of images being scanned, the Photoshop Album Getting Photos dialog box will appear for only an instant, or for several seconds, with a status bar tracking the importing of the photos from the scanner. Once the import is done, the dialog box will close automatically and an alert dialog box will remind you that Photoshop Album will display only the newly imported photos (see the first *Tip* on page 6.).

5. Click *OK* to close the alert dialog box and Photoshop Album will display the newly imported photos in the Photo Well (**Figure 1.22**).

<div style="float: left;">
</div>

Importing Files from Your Computer

Photoshop Album offers two different ways to import photos already stored on your computer. If you have some specific files you want to import, Photoshop Album will let you navigate to them. But you also probably have lots of photos scattered across your hard drive that you'd rather not hunt down individually. In that case, Photoshop Album will search all your hard drives, present a list of what's found, and leave you the choice of bringing them into Photoshop Album. If you used Adobe's earlier PhotoDeluxe or ActiveShare programs to organize your photos, it's easy to import them right into Photoshop Album (see page 14). By the way, all these imported images will remain in their original locations. Photoshop Album simply creates a proxy image in its catalog that points back to the original, enabling you to organize hundreds of already existing images from within Photoshop Album *without* needing a lot of hard drive space. If you ever move the original image, you'll need to find it when you use Photoshop Album to create a backup catalog. For more information, see page 62.

To import specific photos from your computer:

1. Click the Quick Guide's *Get Photos* icon or tab and then click the *File Folders* icon when it appears (**Figure 1.23**).

 or

 In the Shortcuts bar, choose Get Photos > From Files and Folders ([Ctrl][Shift][G]) (top, **Figure 1.24**).

 or

 From the Menu bar, choose File > Get Photos > From Files and Folders ([Ctrl][Shift][G]) (bottom, **Figure 1.24**).

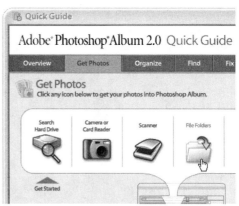

Figure 1.23 Use the Quick Guide to find specific photos on your computer by clicking the *File Folders* icon under the *Get Photos* tab.

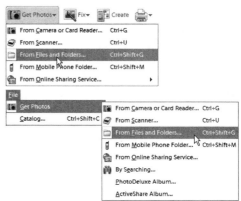

Figure 1.24 You also can find photos by using the Shortcuts bar to choose Get Photos > From Files and Folders (top) or using the Menu bar to choose File > Get Photos > From Files and Folders ([Ctrl][Shift][G]) (bottom).

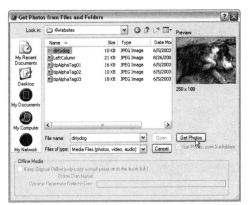

Figure 1.25 Navigate to the folder where your files reside, select them, and click *Get Photos* (Shift)-click to select multiple files).

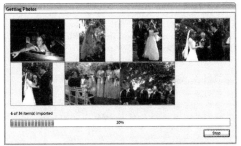

Figure 1.26 The Getting Photos dialog box displays the photos as they are imported from your hard drive.

2. When the Get Photos from Files and Folders dialog box appears, navigate to the folder where your files reside, select them, and click *Get Photos* (**Figure 1.25**). Use (Shift)-click to select more than one file.

3. The Getting Photos dialog box will appear with a status bar that tracks the photos being imported (**Figure 1.26**). Once the import is done, the dialog box will close automatically and an alert dialog box will remind you that Photoshop Album will display only the newly imported photos (see the first *Tip* on page 6).

4. Click *OK* to close the alert dialog box and Photoshop Album will display the newly imported photos in the Photo Well. You now can work with your new photos.

IMPORTING FILES FROM YOUR COMPUTER

11

To search your computer for photos:

1. Click the Quick Guide's *Get Photos* icon or tab and then click the *Search Hard Drive* icon when it appears (top, **Figure 1.27**).
 or
 From the Menu bar, choose File > Get Photos > By Searching (bottom, **Figure 1.27**).

2. When the Get Photos By Searching for Folders dialog box appears, use the *Look In* drop-down menu to select which drives should be searched (**Figure 1.28**). Checked by default, the *Exclude System and Program Folders* and *Exclude Files Smaller Than* boxes ensure that you don't wind up grabbing thousands of irrelevant or tiny images. Make sure *Preview* is checked, then click *Search*. Depending on the size of the hard drive, it may take a minute or so to display the results, which will be listed by folder.

3. Choose a folder in the *Search Results* panel and the images it contains will be displayed in the right-hand *Preview* panel (**Figure 1.29**). Once you find the folder you want (Ctrl-click to select multiple folders), click *Import Folders*.

4. The Getting Photos dialog box will appear with a status bar that tracks the photos being imported. Once the import is done, the dialog box will close automatically and an alert dialog box will remind you that Photoshop Album will display only the newly imported photos (see the first *Tip* on page 6).

5. Click *OK* to close the alert dialog box and Photoshop Album will display the newly imported photos in the Photo Well.

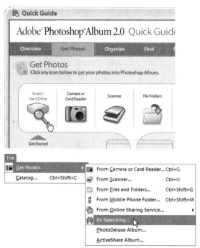
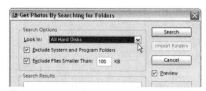

Figure 1.27 Search your computer for photos by clicking the Quick Guide's *Search Hard Drive* icon under the *Get Photos* tab (top). Or from the Menu bar, choose File > Get Photos > By Searching (bottom).

Figure 1.28 Use the *Look In* drop-down menu to select whether to search one or all your hard drives.

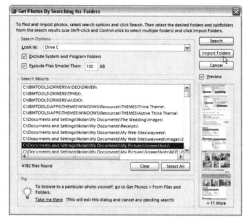

Figure 1.29 Choose a folder in the *Search Results* panel and its images will appear in the right-hand *Preview* panel.

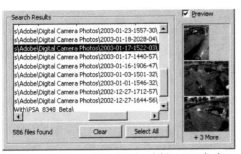

Figure 1.30 Not surprising: the hard drive search also finds all your Photoshop Album photos, which you don't want to import twice.

✔ Tips

- In general, you should not click the *Select All* button in the Get Photos By Searching for Folders dialog box unless you're searching a secondary hard drive free of application-related images. Otherwise, you'll wind up cluttering your Photoshop Album catalog with literally thousands of irrelevant images.

- Not surprisingly, the search will find all the photos you've already imported into Photoshop Album (**Figure 1.30**). You don't need to import them again, but if you forget and try anyway, Photoshop Album will display a reminder dialog box that you have already imported them.

Rights and Copyright

Just because a photo exists on your hard drive does not necessarily mean it's yours to use as you please. Many applications, for example, include tutorials which often include copyrighted photos. If you're ever in doubt, don't add the photos to your Photoshop Album catalog or use them in Album-related projects. Photos emailed to you by friends are fine to use—if it's for private, non-commercial purposes such as posting a print on the fridge. If you're going to use them in something public like a book, however, be sure to get written permission first. (Again, my thanks to my friends for granting permission to use some wonderful photos emailed from around the globe. See page ii for credits.)

To import photos from PhotoDeluxe or ActiveShare albums:

1. From the Menu bar, choose File > Get Photos > PhotoDeluxe Album or File > Get Photos > ActiveShare Album (**Figure 1.31**).

2. When the Finding PhotoDeluxe Albums or Finding ActiveShare Albums dialog box appears, click *Search* (**Figure 1.32**).

3. A list of the albums will appear in the Search Results panel. Once you find the album you want ([Ctrl]-click to select multiple albums), click *Import Album*.

4. The Getting Photos dialog box will appear with a status bar that tracks the photos being imported. Once the import is done, the dialog box will close automatically and an alert dialog box will remind you that Photoshop Album will display only the newly imported photos (see the first *Tip* on page 6).

5. Click *OK* to close the alert dialog box and Photoshop Album will display the newly imported photos in the Photo Well.

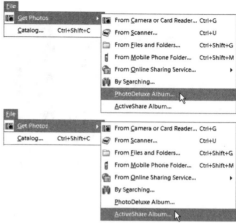

Figure 1.31 To import old PhotoDeluxe or ActiveShare albums, choose File > Get Photos > PhotoDeluxe Album (top) or File > Get Photos > ActiveShare Album (bottom).

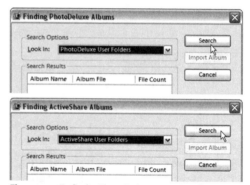

Figure 1.32 To find a PhotoDeluxe or ActiveShare album, click *Search*.

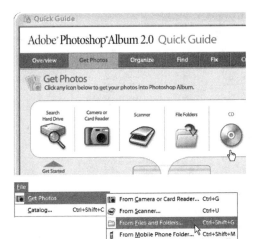

Figure 1.33 Use the Quick Guide to import photos from a CD by clicking the *CD* icon under the *Get Photos* tab. To import from a CD or DVD, choose File > Get Photos > From Files and Folders ([Ctrl] [Shift] [G]) (bottom).

Importing Photos from a CD or DVD

CDs and DVDs can easily store hundreds (or thousands) of images. When you're working with photos on these discs, Photoshop Album gives you the option of copying them to your hard drive, which potentially can take a lot of space, or simply creating proxy images that point back to the photo on the disc. When you want to edit the original, the proxy will help you find the CD or DVD where the original is stored. For more information on burning your photos to CDs or DVDs, see pages 151–152. Obviously your computer must have a DVD drive to use DVDs.

To import photos from a CD or DVD:

1. Insert the CD or DVD into your computer's disc drive. If you're using a CD, you can click the Quick Guide's *Get Photos* icon or tab and then click the *CD* icon when it appears (top, **Figure 1.33**).

 or

 If you're using a CD or DVD, from the Menu bar, choose File > Get Photos > From Files and Folders ([Ctrl] [Shift] [G]) (bottom, **Figure 1.33**).

(continued on next page)

2. When the Get Photos from Files and Folders dialog box appears, navigate to the disc folder where your images reside, select them (⟮Shift⟯-click to select more than one file), and click *Get Photos* (**Figure 1.34**). By default, Photoshop Album only searches for multimedia files. Use the *Files of type* drop-down menu if you want to search for other file types.

or

If you want to leave the original image on the disc and just create a thumbnail reference (also called a proxy), select *Keep Original Offline* (**Figure 1.35**). It's also a good idea to add information to the *Optional Reference Note for Disc* text field to help you find the original disc if you need to hunt it down later. When you're ready, click *Get Photos*.

3. The Getting Photos dialog box will appear with a status bar that tracks the photos being imported. Once the import is done, the dialog box will close automatically and an alert dialog box will remind you that Photoshop Album will display only the newly imported photos (see the first *Tip* on page 6).

4. Click *OK* to close the alert dialog box and Photoshop Album will display the newly imported photos in the Photo Well.

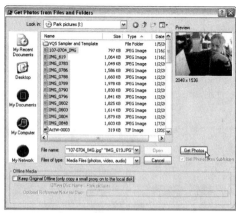

Figure 1.34 Navigate to the folder on the CD or DVD where your images reside, select them, and click *Get Photos*.

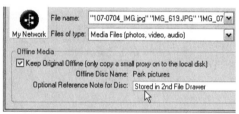

Figure 1.35 If you want to leave the original image on the disc and just create a thumbnail reference, select *Keep Original Offline*.

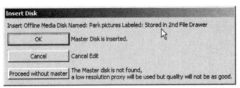

Figure 1.36 A disc icon in the upper left of a thumbnail image indicates that the original is stored on a disc.

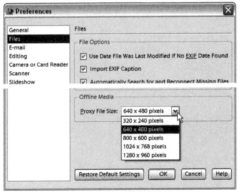

Figure 1.37 If you want to edit an image whose original is stored on a disc, Photoshop Album will display a note to help you find it.

✔ Tips

■ If you selected *Keep Original Offline* in step 3, the imported thumbnail image will include a disc icon to indicate that the original is stored on a disc (**Figure 1.36**). If you want to edit the original image after you've put away the disc, Photoshop Album will help you find it using the note you added in step 3 (**Figure 1.37**).

■ By default, Photoshop Album creates a 640-by-480 pixel thumbnail image for its catalog. That's big enough to see without taking up too much space. If you want Photoshop Album to create larger or smaller thumbnails, choose Edit > Preferences > Files and use the Preferences dialog box's *Proxy File Size* drop-down menu to choose another default (**Figure 1.38**). Once you make your choice, click *OK* to close the dialog box.

Figure 1.38 To create larger or smaller thumbnails, choose Edit > Preferences > Files and make a choice in the Preferences dialog box's *Proxy File Size* drop-down menu.

Importing Photos from a Mobile Camera Phone

As mobile phones equipped with cameras grow more popular, Photoshop Album stands ready to keep those photos organized as well. If your phone stores its photos on a memory card, you can use a card reader to transfer the photos to your computer in the same way you use a camera's memory card. For more information, see *To import photos from a card reader* on page 7. If your phone uses a cable or wireless connection to move photos to your computer, see your phone's instructions on how to set the destination folder for those photos.

You'll then need to tell Photoshop Album which folder holds the photos. Once that's done, Photoshop Album will automatically check that folder for new photos and offer to bring them into Photoshop Album's catalog. For more information, see *To set mobile camera phone preferences* below. You also can send photos from Photoshop Album back to your camera phone. For more information, see *Sharing Photos with Phones and PDAs* on page 144.

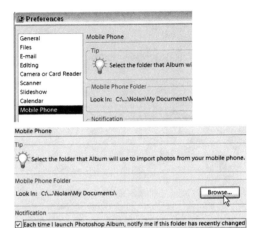

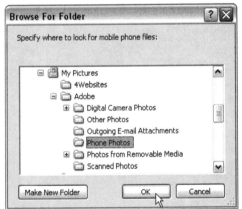

Figure 1.39 When the Preferences dialog box appears, choose *Mobile Phone* in the left-hand list (top), then click *Browse* in the *Mobile Phone Folder* section (bottom).

Figure 1.40 Create a new folder called *Phone Photos* inside the *Adobe* folder where Photoshop Album stores the rest of your photos.

To set mobile camera phone preferences:

1. Choose Edit > Preferences ([Ctrl][K]).

2. When the Preferences dialog box appears, choose *Mobile Phone* in the left-hand list (top, **Figure 1.39**). Next, click the *Browse* button in the dialog box's *Mobile Phone Folder* section (bottom, **Figure 1.39**).

3. If you've already used your phone to set up a destination folder for photos, navigate to that folder. If not, you may find it simpler to create a new folder called *Phone Photos* inside the folder where Photoshop Album stores the rest of your photos (C:\Documents and Settings\YOUR USER NAME\My Documents\My Pictures\ Adobe\) (**Figure 1.40**). Once you designate the folder, click *OK* to close the browse dialog box.

4. When the Preferences dialog box reappears, look in the *Notification* section to be sure that *Each time I launch Photoshop Album, notify me if this folder has recently changed* is checked (bottom, **Figure 1.39**). Click *OK* again to close the Preferences dialog box.

✔ Tip

- By selecting the checkbox in step 4, you'll ensure that Photoshop Album will watch the phone pictures folder and automatically import into the catalog any photos moved there from your phone. If you leave the box unchecked, you can still manually import photos from the folder. For more information, see page 20.

IMPORTING FROM A MOBILE CAMERA PHONE

To manually import photos from a mobile camera phone:

1. Follow your phone's instructions on how to transfer the phone's photos into the folder you designated in *To set mobile camera phone preferences* on page 19.

2. Start Photoshop Album. Click the Quick Guide's *Get Photos* icon or tab and then click the *Mobile Phone* icon when it appears (Ctrl Shift M) (**Figure 1.41**).

 or

 In the Shortcuts bar, choose Get Photos > From Mobile Phone Folder (Ctrl Shift M) (top, **Figure 1.42**).

 or

 From the Menu bar, choose File > Get Photos > From Mobile Phone Folder (Ctrl Shift M) (bottom, **Figure 1.42**).

3. If you designated a target folder in step 3 on page 19, the Getting Photos dialog box will appear with a status bar that tracks the photos being imported. Once the import is done, the dialog box will close automatically and an alert dialog box will remind you that Photoshop Album will display only the newly imported photos.

4. Click *OK* to close the alert dialog box and Photoshop Album will display the newly imported photos in the Photo Well.

✔ Tip

- In step 3, if you haven't already set up a target folder the Specify Mobile Phone Folder dialog box will appear automatically (**Figure 1.43**). Click *Browse* and navigate to where you want to create a new folder to hold your mobile phone's photos.

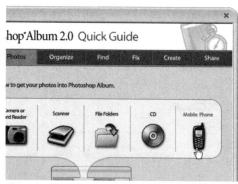

Figure 1.41 Click the *Mobile Phone* icon when it appears under the Quick Guide's *Get Photos* tab.

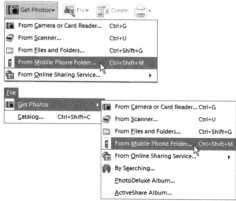

Figure 1.42 You also can import the photos by using the Shortcuts bar to choose Get Photos > From Mobile Phone Folder (top) or using the Menu bar to choose File > Get Photos > From Mobile Phone Folder (Ctrl Shift M) (bottom).

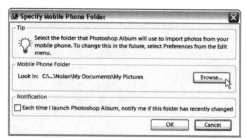

Figure 1.43 if you haven't already set a target folder, the Specify Mobile Phone Folder dialog box will appear. Click *Browse* to set the folder.

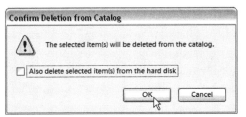

Figure 1.44 When you try to delete an image, a warning dialog box offers you the choice of deleting just the thumbnail or the original as well.

Deleting Photos from Photoshop Album

Given the itty-bitty screens on most digital cameras and camera phones, you may not be able to tell if a photo is worth keeping until after you import it into Photoshop Album. Lots of photo problems, such as red eye, can be fixed. Fuzzy focus, eyes shut, accidental shots of the sky—you're better off deleting them now. That way you can concentrate on working with all the great shots you did get.

To delete photos from Photoshop Album:

1. Within the Photo Well, click on any image you want to delete (Ctrl-click to select multiple images). The selected items will be surrounded with a bright yellow border.

2. Press Delete and when the Confirm Deletion from Catalog dialog box appears (**Figure 1.44**), you have two choices: Click *OK* immediately to delete just the thumbnail (proxy) image from the Photoshop Album catalog. Or select *Also delete selected item(s) from the hard disk* and then click *OK* to remove the original image from your computer as well.

✔ Tip

■ In step 2, if you imported the image directly into Photoshop Album and decide you don't want to use it, then you'll probably also want to remove the original from your hard drive. Unfortunately, there's no way to have the delete-from-hard-disk option checked by default.

VIEWING AND ORGANIZING PHOTOS

2

This chapter covers three tools for organizing your photos: captions and notes, tags, and collections. Each has a different role. Use captions and notes to add details about specific photos. Tags are used to label groups of photos that have things in common. Collections, new in Photoshop Album 2, offer a great way to create different views of those same photos.

Most of your captions will inevitably contain unique descriptions that can help you find a single photo among hundreds of images. In contrast, the tags you create should apply to broad recurring categories. While "Jodi wins baseball championship" makes a great caption for a few photos, it's too specific for a tag—unless you have 30–40 photos of that game. "Little League" or "Family-Jodi" might be examples of a more useful tag. Tags don't tell you much about individual photos, but they do help you find a group of photos likely to contain the one photo you want to see. For more information on captions, see page 31. For more information on tags, see page 38.

At first, collections might seem to duplicate the function of tags. But while tags act as markers for individual photos, each collection holds a group of photos. Take the time to work with collections and you'll soon wonder how you got along without them.

Working with Photos

The Photo Well lets you vary your view of the photos, depending on your task. With the new thumbnail slider, you can zoom in to see just one photo or zoom out to see dozens of photos as tiny thumbnails—or any view in between. To compare similar shots for editing, setting the thumbnail slider somewhere in the middle works well (**Figure 2.1**). If you want to see which photos need fixing or cropping, the single-photo view works best (**Figure 2.2**). You can even see a full-screen sequence of photos you select in what Photoshop Album calls an instant slideshow. You also can view any of your video clips directly in the Photo Well. For more information on bringing photos and videos into Photoshop Album, see *Getting Photos* on page 1.

To change photo sizes in the Photo Well:

◆ Click and drag the thumbnail slider at the bottom of the Options bar or click one of the buttons on either side of the slider to jump immediately to the smallest or largest view (**Figure 2.3**).

✔ Tips

■ No matter what size you are displaying photos, you can move forward or backward through the sequence by pressing ⊞ or ⊟.

■ To display any selected photo at full screen size, press F11. To deactivate the full-screen view, click your cursor once. By the way, even when using the full-screen mode, you can move forward or backward through the sequence by pressing ⊞ or ⊟.

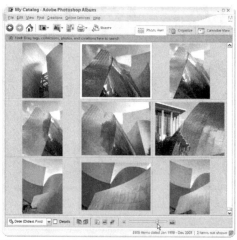

Figure 2.1 To compare similar shots for culling, set the thumbnail slider in the middle of its range.

Figure 2.2 The single-photo view works best for inspecting photos that might need editing or cropping.

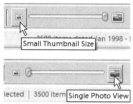

Figure 2.3 To change photo sizes in the Photo Well, drag the thumbnail slider at the bottom of the Options bar or click one of the buttons on either side of the slider to jump immediately to the smallest or largest view.

Figure 2.4
To rearrange the Photo Well view, click the arrangement menu in the Options bar.

Figure 2.5 You also can rearrange the Photo Well view by choosing View > Arrangement and making a choice from the drop-down menu.

Figure 2.6 The film roll icon shows that these photos were imported into Photoshop Album at the same time.

Figure 2.7 The folder icon shows that these photos are all stored in the same place.

To rearrange the Photo Well view:

◆ Click the Photo Well arrangement menu in the Options bar and make a choice from the pop-up menu (**Figure 2.4**).

◆ From the Menu bar, choose View > Arrangement and make a choice from the drop-down menu (**Figure 2.5**).

◆ Use the keyboard commands (**Figure 2.5**): Ctrl Alt 0 to see the newest photos first, Ctrl Alt 1 to see the oldest first, Ctrl Alt 2 to see by import batch (**Figure 2.6**), or Ctrl Alt 3 to see based on folder location (**Figure 2.7**).

(continued on next page)

REARRANGING THE PHOTO WELL VIEW

✔ Tips

- Arranging the Photo Well with the newest photos first will let you quickly find your freshest photos. By default, the Photo Well is arranged with the oldest photos at the top, which puts the photos you just imported out of sight at the bottom of the well.

- By default, *Details* is checked in the Options bar, enabling Photoshop Album to display the time, date, and tag for each photo. To hide all three—and fit more photos into the Photo Well—uncheck *Details* (**Figure 2.8**).

- You now can display individual file names in the Photo Well by choosing Edit > Preferences, selecting *General* in the left pane, and selecting the *Show File Names in Details* checkbox in the right pane's *Display Options*. Though most times you'll want to leave the names hidden, it can be helpful when trying to spot which photos you've already edited (**Figure 2.9**).

- In **Figure 2.5**, the *Color Similarity* choice is grayed out. For more information on this powerful option, see *Finding Photos of Similar Color* on page 85.

Figure 2.8 To hide the photo's time, date, and tag—and fit more photos into the Photo Well—uncheck *Details*.

Figure 2.9 Photoshop Album version 2's ability to display file names in the Photo Well can be helpful when trying to spot photos you've already edited.

Figure 2.10 To view an instant slideshow, click the Slideshow icon (top) or choose View > Slideshow (bottom).

Building slideshow ...

Figure 2.11 A Building slideshow alert box will appear while Photoshop Album assembles the photos.

Figure 2.12 A mini-control panel will appear in the screen's upper right, which you can use to move through or stop the slideshow.

To view an instant slideshow:

1. In the Photo Well, select the photos you want to see in a full-screen instant slideshow. ([Shift]-click to select adjacent photos or [Ctrl]-click to select non-adjacent photos.)

2. In the Shortcuts bar, click the Slideshow icon or from the Menu bar, choose View > Slideshow ([Ctrl]-Space) (**Figure 2.10**). A Building slideshow alert box will appear while Photoshop Album assembles the photos into a slideshow (**Figure 2.11**). The photos will then appear full-screen. A mini-control panel will appear in the screen's upper right, which you can use to move through or stop the slideshow (**Figure 2.12**). Click anywhere on the screen to return to the Photoshop Album Photo Well.

✔ Tip

■ Such instant slideshows display photos in the order they appear in the Photo Well, and you cannot change that order. To create a slideshow with the photos shown in a particular order, see *Creating Slideshows* on page 116.

VIEWING AN INSTANT SLIDESHOW

To play a video clip:

◆ In the Photo Well, double-click the video clip you want to see (**Figure 2.13**). When the video clip window appears, click the big center play button (**Figure 2.14**). Click the X icon to close the video window and return to the Photo Well.

✔ Tip

■ The Photoshop Album Creations Wizard can help you create video CDs; see *Creating Projects* on page 107.

Figure 2.13 To play a video clip (marked by a film strip icon in the upper right), just double-click it.

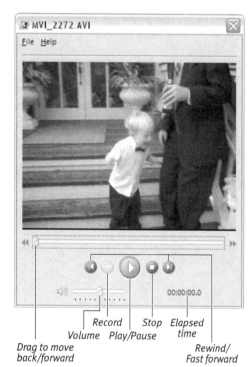

Record Stop Elapsed
Volume Play/Pause time
Drag to move Rewind/
back/forward Fast forward

Figure 2.14 Click the big center play button to start a video clip.

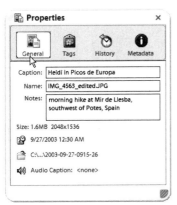

Figure 2.15 The *General* view of the Properties window displays each photo's caption, file name, notes, and a variety of other information.

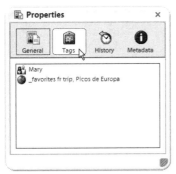

Figure 2.16 The *Tags* view of the Properties window displays all the tags applied to the selected photo.

Figure 2.17 The *History* view of the Properties window tells you when a photo was changed, when and where it was imported, and whether any prints have been made.

Viewing, Adding or Changing Photo Details

The Properties window contains a storehouse of information about each photo. Some of these details you need to add manually, while others are captured automatically as you work in Photoshop Album. All these details will help you find and improve your photos—plus jog your memory. You can add captions, notes, and even audio captions whenever you have time or just before you create a slideshow or photo book (**Figure 2.15**). For more information on slideshows and other Photoshop Album projects, see page 107. Details captured automatically can be found in the window's Tags view, which shows what tags have been attached to a photo (**Figure 2.16**); the History view, which shows when a photo was last edited, or printed (**Figure 2.17**); and the Metadata view, which captures your camera's settings for each photo. Available in a summary or detailed form (**Figure 2.18**), such metadata can be very helpful for understanding why some photos look great and others turn out blurry or improperly exposed.

Figure 2.18 By choosing the *Brief* button in the Properties window's *Metadata* view, you can get a quick summary of camera settings for a photo (top left), while choosing *Complete* lets you see the nitty-gritty details (bottom right).

To show or hide the Properties window:

◆ Click the Show/Hide Properties icon in the Options bar (top, **Figure 2.19**), or from the Menu bar, choose View > Properties ([Alt][Enter]). The Properties window will open.

Or

◆ Right-click any photo in the Photo Well and choose Show Properties ([Alt][Enter]) (bottom, **Figure 2.19**). The Properties window will open.

✔ Tips

■ You can close the Properties window by clicking the X button in the upper-right corner. But if you leave it open, you can quickly see the details of any photo selected in the Photo Well. Positioning the window off to the side will keep it from blocking your work in the Photo Well.

■ While all that metadata captured from your digital camera might seem a bit exotic, you'll find it immensely helpful as you begin editing photos and want to understand why certain photos turn out better than others.

Figure 2.19 To show or hide the Properties window, click the Show/Hide Properties icon in the Options bar (top), or right-click a photo and choose Show Properties ([Alt][Enter]) (bottom).

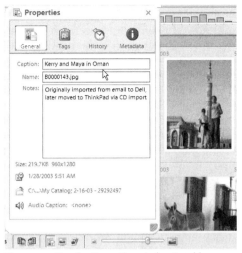

Figure 2.20 Use the Properties window to add captions, notes, and even audio captions to a photo.

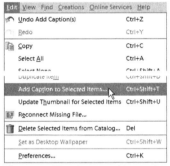

Figure 2.21 You also can add a caption to multiple photos by selecting them and choosing Edit > Add Caption to Selected Items ([Ctrl] [Shift] [T]).

To add photo caption(s):

◆ If the Properties window is open, select a photo in the Photo Well, and you can type the caption directly in the Properties window's *Caption* text window (**Figure 2.20**). When you're done, press [Tab] or [↵Enter] to apply the caption to the photo.

Or

◆ To add the same caption to several photos, select the photos in the Photo Well ([Shift]-click to select adjacent photos; [Ctrl]-click to select non-adjacent photos). Choose Edit > Add Caption to Selected items ([Ctrl] [Shift] [T]) (**Figure 2.21**). When the Properties window appears, type in the *Caption* text window. When you're done, press [Tab] or [↵Enter] to apply the caption to the photos.

(continued on next page)

ADDING PHOTO CAPTIONS

Or

◆ Double-click any photo in the Photo Well and a *Click here to add caption* text window will appear below the photo (**Figure 2.22**). Click within the window and type in your caption (**Figure 2.23**). When you're done, press ⌨Tab or ⌨←Enter to apply the caption to the photo.

✔ Tips

■ A caption can be no longer than 63 characters.

■ New in version 2 of Photoshop Album, the ability to apply the same caption to multiple photos is very handy if, for example, you have a group of photos taken in the same place or at the same event.

To remove a photo caption:

1. Select one or more photos in the Photo Well (⌨Shift-click to select adjacent photos; ⌨Ctrl-click to select non-adjacent photos).

2. From the Menu bar, choose Edit > Clear Caption or Edit > Clear Captions of Selected Items. The captions will be removed from the selected photos.

3. When the Confirm Clearing of Captions(s) dialog box appears, click *Yes*. The captions will be deleted and the Photo Well will reappear.

To add a note to a photo:

◆ Make sure the Properties window is open, select a photo in the Photo Well, and type in the Properties window's *Notes* text window.

✔ Tip

■ You can type up to 1,023 characters in a note, which lets you add a fair amount of detail (**Figure 2.20**). If the notes are made while your memory is fresh, they can serve as a photo diary or field journal.

Figure 2.22 Double-click any photo in the Photo Well (top) and a *Click here to add caption* text window will appear under the photo (bottom).

Figure 2.23 Click within the text window, type in your caption, and press ⌨Tab or ⌨←Enter to apply it to the photo.

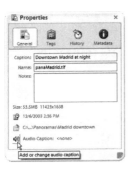

Figure 2.24
To add an audio caption, click the *Audio Caption* button in the Properties window.

Figure 2.25
When the Select Audio File dialog box appears, choose File > Browse to navigate to an audio file already on your computer.

Figure 2.26 Use the Specify Audio File dialog box to navigate to the desired file and open it.

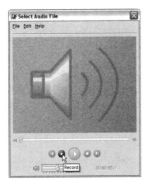

Figure 2.27
To attach spoken notes to a photo, make sure your USB-enabled microphone is attached and click the record button to start recording.

To add an audio caption:

1. Make sure the Properties window is open, select a photo in the Photo Well, and click the *Audio Caption* icon in the Properties window (**Figure 2.24**).

2. When the Select Audio File dialog box appears, choose File > Browse if there's an audio file already on your computer that you want to attach to the photo (**Figure 2.25**). Use the Specify Audio File dialog box to navigate to the desired file and then open it (**Figure 2.26**). (See the *Tip* on where you can find some audio files that came with Photoshop Album.)

 If you want to attach some spoken notes to the photo, make sure your USB-enabled microphone is attached and click the red record button to start recording (**Figure 2.27**). When you're done and want to stop recording, click the record button again.

(continued on next page)

ADDING AN AUDIO CAPTION

3. Once you've found or made an audio clip for the photo, close the Select Audio File dialog box by clicking the X icon in the upper right, and when the Save Changes dialog box appears, click *Yes* (top, **Figure 2.28**). The name of the attached audio file will appear in the Properties window next to the Audio Caption icon (bottom, **Figure 2.28**).

✔ Tips

- If you want to experiment with the audio caption feature but don't have any appropriate files on your computer, navigate on your C drive to: `/PhotoshopAlbum/Shared_ Assets/AtmosphereWebGallery/` and look in any of the enclosed folders (**Figure 2.29**).

- Audio captions cannot be added to video clips that already have an audio track.

To remove an audio caption:

1. Click the Audio Caption button in the Properties window and when the Select Audio File dialog box appears, choose Edit > Clear (**Figure 2.30**).

2. When the Save Changes dialog box appears, click *Yes* (top, **Figure 2.28**). The name of the attached audio file will no longer appear in the Properties window next to the Audio Caption button.

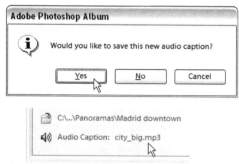

Figure 2.28 After finding or creating an audio file, click *Yes* to save it (top), and it will then appear in the Properties window (bottom).

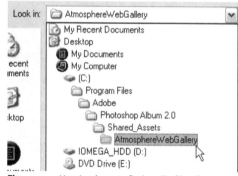

Figure 2.29 Here's where to find audio files if you want to experiment with the audio caption feature.

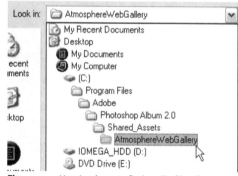

Figure 2.30 To remove an audio caption from a photo, choose Edit > Clear.

ADDING, REMOVING AN AUDIO CAPTION

To rename a photo:

1. Select the photo in the Photo Well and from the Menu bar, choose File > Rename (Ctrl Shift N).

2. When the Rename dialog box appears, type in the *New Name* text window and click *OK*. The name of the file will be changed.

✔ Tip

■ Though you may want to rename a photo, resist with all your might the temptation to do this more than occasionally. The reason? Photoshop Album was designed to make it unnecessary to worry about what a digital photo might be named. If you start renaming files just for the sake of tidiness, you'll be missing the real fun of having digital photos, which is to create cool projects with them.

RENAMING A PHOTO

To change a photo's date or time:

1. Make sure *Details* is selected in the Options bar at the bottom of the Photo Well. Click to select a photo within the Photo Well (Shift-click adjacent photos or Ctrl-click non-adjacent photos).

2. Within the Photo Well, press Ctrl J or click the date or time stamp above the selected photo(s) (top, **Figure 2.31**) or right-click the photo(s) and choose *Adjust Date and Time of Selected Items* (bottom, **Figure 2.31**).

3. When the Adjust Date and Time dialog box appears, *Change to a specified date and time* will be selected by default (**Figure 2.32**). The second choice lets you reset the date and time of when the photo was first imported into Photoshop Album, while the last choice lets you quickly shift, for example, from 1 a.m. to 1 p.m. Make your choice and click *OK*.

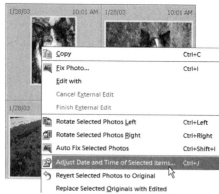

Figure 2.31 Click the date or time above the selected photo (top) or right-click and choose *Adjust Date and Time of Selected Items* (bottom).

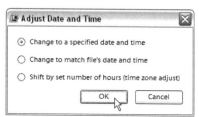

Figure 2.32 Use the Adjust Date and Time dialog box to change the date, time, or shift the time zone for the selected photos.

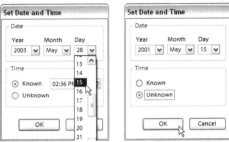

Figure 2.33 Use the *Year*, *Month*, and *Day* drop-down menus to change the date (left). Select *Unknown* if you don't know what time the photo was taken (right).

4. When the Set Date and Time dialog box appears, use the *Year*, *Month*, and *Day* drop-down menus to change the settings (left, **Figure 2.33**). Within the *Time* panel, use the arrows on the right side of the *Known* text field. If you don't know what time the photo was shot—or don't want to specify that—select *Unknown*. Click *OK* when you're done (right, **Figure 2.33**). The selected photo(s) in the Photo Well will reflect the date and time changes (**Figure 2.34**).

Figure 2.34 The new date will appear above the photo in the Photo Well.

Working with Date and Time Changes

The date and time displayed for a photo will vary depending on the photo's original source. If you imported the photo from a digital camera or a card reader, the date and time reflect the time the photo was taken (assuming the camera's clock is set properly). If you import a photo from a CD or a file already on your computer, the date and time reflect when the file was first created. Photos from a scanner show the date and time when the image was imported into Photoshop Album. If all your digital camera photos are off by 12 hours (showing 2 a.m. when it should be 2 p.m., for example), recheck your camera's clock setting.

The Adjust Date and Time dialog box includes a handy time zone adjust option (**Figure 2.32**), which is a major help when you've taken a trip across the ocean but your camera's clock is set to home time. However, you cannot apply the time zone shift to photos that you've found using Photoshop Album's Find/Tag features. That's unfortunate since it would make it easier, for example, to find all those photos from your Spain vacation. Instead, you'll have to select them manually in the Photo Well (though, at least, you can select multiple photos). One more trick: If the Photo Well view is set to Date (Oldest First) or Date (Newest First), applying the time shift will reshuffle the well's viewing order of the Photo Well. Setting the Photo Well view to Import Batch or Folder Location makes it easier to keep track of your changes.

CHANGING A PHOTO'S DATE OR TIME

Working with Tags

Before Photoshop Album came along, you often faced a quandary when organizing and filing your prints and slides. Should you arrange them by date, by trip, by subject? With tags, you can quickly file your photo prints in multiple ways—without reshuffling the photos themselves. Remember: Tags don't actually change your photos. Instead Photoshop Album stores the tag information in the behind-the-scenes catalog. For more information, see *Working with Catalogs* on page 61.

To show or hide the Tags pane:

◆ In the Photo Well, click the *Organize* tab (top, **Figure 2.35**) and the Tags pane will appear (**Figure 2.36**).

Or

◆ In the Menu bar, choose View > Organize View (bottom, **Figure 2.35**) and the Tags pane will appear (**Figure 2.36**).

✔ Tip

■ You also can close the Tags pane by clicking either the *Photo Well* or *Calendar View* tab (**Figure 2.37**).

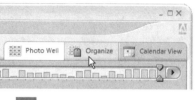

Figure 2.35 To show or hide the Tags pane, click the *Organize* tab in the Photo Well (top) or from the Menu bar, choose View > Organize View (bottom).

Figure 2.36
The Tags pane makes it easy to add, remove, change, or rearrange tags.

Figure 2.37 You can close the Tags pane by clicking either the *Photo Well* or *Calendar View* tab.

Figure 2.38
Choose View > Tag Viewing Options to change the display size for tags.

Figure 2.39
By default, the middle choice is selected in the Tag Options dialog box.

To change the Tags pane view:

1. From the Menu bar, choose View > Tag Viewing Options (**Figure 2.38**). When the Tag Options dialog box appears, the middle choice is selected by default (**Figure 2.39**).

2. Select the top choice to display smaller tags without thumbnail images, or the bottom choice to use tags with even larger thumbnails (**Figure 2.40**). Click *OK* to close the Tag Options dialog box and the Tags pane will reflect the change.

✔ Tip

- In step 2, if you check the *Alphabetical Order* option, the Tags pane will display your tags without the hierarchy of categories and subcategories (**Figure 2.41**). You may find the alphabetical view easier to use for certain tasks, though the category/subcategory view is the most versatile.

Figure 2.40 Two other tag display options: smaller tags without photos (left) or tags with even larger photos (right).

Figure 2.41
Switching to the *Alphabetical Order* option displays your tags without the hierarchy of categories and subcategories.

CHANGING THE TAGS PANE VIEW

To create a new tag:

1. With the Tags pane visible, click the *New* button in the Tags toolbar and choose New Tag from the drop-down menu ([Ctrl][N]) (**Figure 2.42**).

2. When the Create Tag dialog box appears, choose a *Category* (or a sub-category if you've created any) using the drop-down menu (left, **Figure 2.43**). For more information on creating categories and sub-categories or organizing tags, see pages 46–54.

3. Use the *Name* text window to give your tag a short but descriptive name, add any needed extra information in the *Note* field, then click *OK* (right, **Figure 2.43**). The dialog box will close and the new tag will appear in the Tags pane under the assigned category or sub-category (**Figure 2.44**).

✔ Tips

- The icon for the new tag will remain *?* until you attach it to a photo.

- In step 1, if you first click on a particular tag category or sub-category, Photoshop Album will automatically assign your new tag to that category (**Figure 2.45**).

- You also can create a new tag within a particular category or sub-category by right-clicking on it and then using the shortcut menu to choose *Create new tag in [name of] sub-category* (**Figure 2.46**).

Figure 2.46 By right-clicking a tag, you can create a new tag within that category or sub-category.

Figure 2.42
To create a new tag, click the *New* button in the Tags toolbar and choose New Tag from the drop-down menu ([Ctrl][N]).

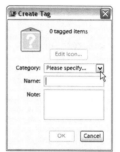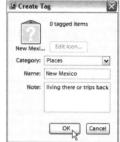

Figure 2.43 Choose a *Category* (or a sub-category if you've created any) using the drop-down menu (left), then give your tag a name and add extra information in the *Note* text window (right).

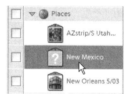

Figure 2.44
The new tag will appear in the Tags pane under the assigned category or sub-category.

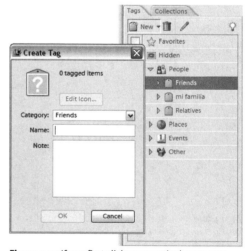

Figure 2.45 If you first click on a particular tag category or sub-category, Photoshop Album will automatically assign your tag to that category.

Figure 2.47 To attach tags to a single photo, click and drag any tag from the Tags pane onto a photo in the Photo Well.

Figure 2.48 The tag's icon appears briefly after attaching it to a photo (top). Roll the cursor over the category icon to see the name of the attached tag (bottom).

To attach tags to a single photo:

◆ Click and drag any tag from the Tags pane onto a photo in the Photo Well (**Figure 2.47**). Release your cursor and the tag will be applied to the photo, with the tag icon briefly appearing atop the photo (top, **Figure 2.48**). An icon representing the tag's category will appear in the lower-left corner of the photo (bottom, **Figure 2.48**).

✔ Tips

■ If you roll your cursor over the category icon in the photo's lower-left corner, you can immediately see the name of the attached tag (bottom, **Figure 2.48**).

■ Be sure the *Details* box is checked in the Options bar, otherwise tag icons will not appear in the Photo Well.

■ As you can see in **Figure 2.48**, the *?* previously shown as the tag icon has been replaced by a thumbnail of the attached photo. To change the thumbnail image applied to the tag icon, see page 49.

■ Remember that you can attach multiple tags to the same photo, such as "New Mexico," "Summer Trip," and "Ray & Kerry." For more information on organizing your tags, see page 38.

To attach tags to multiple photos:

1. Within the Photo Well, (Shift)-click to select adjacent photos or (Ctrl)-click to select non-adjacent photos. Each selected photo will be surrounded by a bright yellow border.

2. Click and drag any tag from the Tags pane onto any of the selected photos (**Figure 2.49**). Release your cursor and the tag will be applied to the photos (**Figure 2.50**).

 or

 Right-click any of the selected photos, choose *Attach Tag to Selected Items*, and then choose the tag you want from the submenus that appear.

Figure 2.49 To attach tags to multiple photos, drag any tag from the Tags pane onto any of the selected photos.

Figure 2.50 The tag after being applied to all three photos.

Figure 2.51 Click the film roll icon to select all the photos in that particular import batch.

Figure 2.52 The selected tag after being attached to all the photos in a particular folder.

To attach a tag to an import batch or folder:

1. Click the Photo Well arrangement menu in the Options bar and choose Import Batch or Folder Location from the pop-up menu.

2. Scroll through the Photo Well until you find the import batch or folder to which you want to attach a tag.

3. In the Photo Well, click the film roll icon for a particular import batch or the folder icon for a folder's worth of images. All the photos in the batch or folder will be selected, with a bright yellow frame around each photo (**Figure 2.51**).

4. Click and drag any tag from the Tags pane onto any of the selected photos.

5. Release your cursor and the tag will be applied to all the photos in the import batch or folder, indicated by the small tag icon in the lower-right of each photo (**Figure 2.52**).

To create tags using folder names:

1. Click the Photo Well arrangement menu in the Options bar and choose Folder Location from the pop-up menu.

2. Scroll through the Photo Well until you find the folder of photos whose name you want to use. Click the *Instant Tag* button to the right of the folder's path name (**Figure 2.53**).

3. When the Create and Apply New Tag dialog box appears, the folder's name will be added to the *Name* text window (left, **Figure 2.54**). Choose a *Category* (or a sub-category if you've created any) using the drop-down menu. Once you've selected the category or sub-category, click *OK* to close the dialog box (right, **Figure 2.54**). The folder-based tag name will be added under the chosen category or sub-category in the Tags pane (**Figure 2.55**).

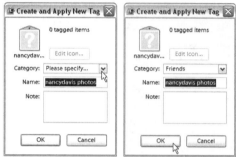

Figure 2.53 Once you find the folder whose name you want to use in a tag, click the *Instant Tag* button.

Figure 2.54 The folder's name will be added to the *Name* text window (left). After selecting a category or sub-category for the new tag, click *OK* (right).

Figure 2.55
The folder-based tag name will be added under the chosen category or sub-category in the Tags pane.

Figure 2.56 To remove tags from selected photos, right-click them and choose Remove Tag > [the tag you want removed].

To remove tags from photos:

1. Within the Photo Well, select the photo with a tag you want to remove (⟨Shift⟩-click to select adjacent photos; ⟨Ctrl⟩-click to select non-adjacent photos).

2. Right-click any of the selected photos and choose Remove Tag > [the tag you want removed] (**Figure 2.56**). The tag(s) will be removed.

Organizing Tags

Photoshop Album has four overall category tags: People, Places, Events, and Other. In version 2, you now can create your own additional categories, plus change the icons for any category. You also can create as many sub-categories as you need within each category. By default, the People category already has two useful sub-categories: Family and Friends, which can be changed to suit your needs. Remember that Photoshop Album automatically tracks your photos by date, which means that you should not be creating sub-categories under the Events category for every month and day. For more information on using the Favorites and Hidden tags, see page 76.

To create a new tag category:

1. With the Tags pane visible, click the *New* button in the Tags toolbar and choose New Category from the drop-down menu (**Figure 2.57**).

2. When the Create New Category dialog box appears, type a name into the *Category Name* text window and scroll through the icons in the *Category Icon* window to pick an appropriate icon (**Figure 2.58**).

3. Click *OK* to close the dialog box and the new category and its icon will appear in the Tags pane (**Figure 2.59**).

Figure 2.57 To create a new tag category, click the *New* button in the Tags toolbar and choose New Category.

Figure 2.58 Type a new name into the *Category Name* text window and scroll through the icons in the *Category Icon* window to pick an appropriate icon.

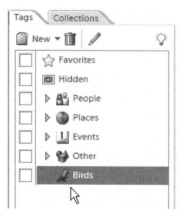

Figure 2.59 The new category and its icon will appear in the Tags pane.

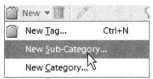

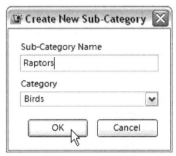

Figure 2.60 To create a new tag sub-category, click the *New* button and choose New Sub-Category.

Figure 2.61 Type a name into the *Sub-Category Name* text window and use the *Category* drop-down menu to pick a category for the sub-category.

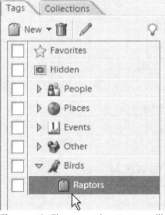

Figure 2.62 The new sub-category will appear within the chosen category in the Tags pane.

To create a new tag sub-category:

1. With the Tags pane visible, click the *New* button in the Tags toolbar and choose New Sub-Category from the drop-down menu (**Figure 2.60**).

2. When the Create New Sub-Category dialog box appears, type a name into the *Sub-Category Name* text window and then use the *Category* drop-down menu to pick an appropriate category within which to place the sub-category (**Figure 2.61**).

3. Click *OK* to close the dialog box and the new sub-category will appear within the chosen category in the Tags pane (**Figure 2.62**).

To change a tag category, name, or note:

1. Within the Tags pane, right-click the tag you want changed and choose *Edit [name of] tag* (top, **Figure 2.63**).

 or

 Within the Tags pane, select the tag you want changed and then click the pencil-shaped edit icon in the Tags toolbar (bottom, **Figure 2.63**).

2. When the Edit Tag dialog box appears, use the *Category* drop-down menu to choose another category (**Figure 2.64**).

3. To change the *Tag Name*, just type a new name into the text window.

4. To change the *Note*, add or delete text in the adjacent text window.

5. Click *OK* to close the dialog box, and the changes will be applied to the tag.

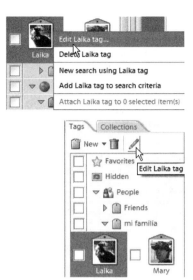

Figure 2.63 To change a tag category, name, or note, right-click on the tag you want changed (top), or click the edit icon in the Tags toolbar (bottom).

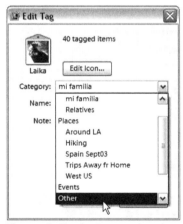

Figure 2.64 Use the *Category* drop-down menu to choose another category.

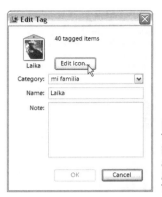

Figure 2.65
To change a tag icon's appearance, click *Edit Icon* in the Edit Tag dialog box.

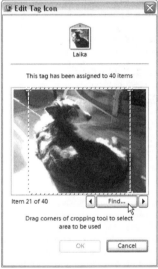

Figure 2.66 Click *Find* to look through all the photos with this tag attached.

Figure 2.67 Once you choose a new photo to use, click *OK* to close the dialog box.

To change a tag icon's appearance:

1. Within the Tags pane, right-click on the tag whose icon you want to change and choose *Edit [name of] tag* (top, **Figure 2.63**).

2. When the Edit Tag dialog box appears, click *Edit Icon* (**Figure 2.65**).

3. When the Edit Tag Icon dialog box appears, click *Find* (**Figure 2.66**).

4. A dialog box will display all the photos with this tag attached (**Figure 2.67**). Make your choice and click *OK* to close the dialog box.

(continued on next page)

CHANGING A TAG ICON'S APPEARANCE

5. When the Edit Tag Icon dialog box reappears, a dashed-line box will surround your new photo choice. Click inside the dashed-line box to recenter the framing and grab its corner to zoom in or out on the photo (**Figure 2.68**). When you finish, click *OK*.

6. The Edit Tag dialog box will reappear and reflect the change (**Figure 2.69**). Unless you need to make other changes, click *OK* to close the dialog box.

✔ Tip

■ At the beginning of step 3, a note above the photo tells you how many items the tag has been applied to. If the number is less than 10, just click the arrows on each side of the *Find* button to quickly scroll through the available icon photos.

Figure 2.68 Click inside the dashed-line box to recenter the framing and grab its corner to zoom in or out on the photo.

Figure 2.69 The Edit Tag dialog box reappears with the new icon choice selected. Click *OK* to close the dialog box.

CHANGING A TAG ICON'S APPEARANCE

Figure 2.70 To reassign tags, right-click on the tag and choose *Edit [name of] tag*.

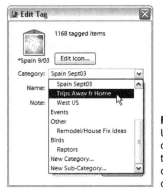

Figure 2.71 Use the *Category* drop-down menu to choose another category or sub-category.

Figure 2.72 After closing the Edit Tag dialog box, the tag will appear under the newly selected category or sub-category.

To reassign tags to another category or sub-category:

1. Within the Tags pane, right-click on the tag you want to reassign and choose *Edit [name of] tag* (**Figure 2.70**).

 or

 Click the edit icon in the Tags toolbar.

 or

 From the Menu bar, choose Tag > Edit Selected Tag.

2. When the Edit Tag dialog box appears, use the *Category* drop-down menu to choose another category or sub-category (**Figure 2.71**).

3. Click *OK* to close the dialog box and the tag will appear under the selected category or sub-category within the Tags pane (**Figure 2.72**).

✔ Tip

■ Within sub-categories, tags are automatically arranged alphabetically. Sub-categories are ordered the same way within categories. In **Figure 2.70,** notice how non-letter characters (such as dashes, underscores, and asterisks) can be used to force often-used tags or sub-categories to the top of the list. Blank spaces cannot be used, however. When entering special characters before the names, if the *OK* button remains dimmed in the Edit Tag or Edit Sub-Category dialog boxes, you'll have to try another character.

REASSIGNING TAGS

To reassign a sub-category or tag by dragging and dropping:

1. With the Tags pane visible, click and drag the sub-category or tag on top of the category to which you want it reassigned (**Figure 2.73**).

2. Release the cursor and the selected sub-category or tag will appear within the target category, reflecting its reassignment (**Figure 2.74**).

✔ Tip

- You cannot use the drag-and-drop method to move a category into a sub-category; nor can you turn a tag or sub-category into a category.

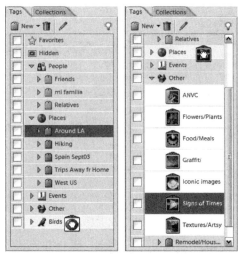

Figure 2.73 Click and drag the sub-category (left) or tag (right) on top of the category to which you want it reassigned.

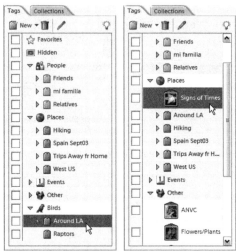

Figure 2.74 Release the cursor and the selected sub-category (left) or tag (right) will appear within the target category, reflecting its reassignment.

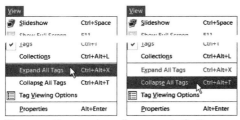

Figure 2.75 To expand or collapse tags in the Tags pane, choose View > Expand All Tags (Ctrl Alt X) or View > Collapse All Tags (Ctrl Alt T).

To expand or collapse the tags view:

◆ From the Menu bar, choose View > Expand All Tags (Ctrl Alt X) or View > Collapse All Tags (Ctrl Alt T) (**Figure 2.75**). Depending on your choice, all the categories and sub-categories will appear in the Tags pane or only your categories will appear (**Figure 2.76**).

✔ Tip

■ To expand or collapse only selected categories or sub-categories, click the left-side triangles in the Tags pane (**Figure 2.77**).

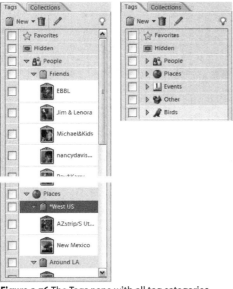

Figure 2.76 The Tags pane with all tag categories expanded (left) and collapsed (right).

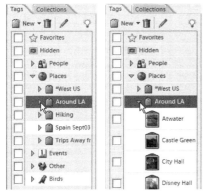

Figure 2.77 To expand or collapse selected categories or sub-categories, click the left-side triangles in the Tags pane.

EXPANDING OR COLLAPSING THE TAGS VIEW

To delete a tag:

1. Click the tag you want to delete and then click the trash icon in the Tags toolbar (top, **Figure 2.78**).

 or

 Within the Tags pane, right-click the tag you want to delete and choose *Delete [Name of] tag* (bottom, **Figure 2.78**).

2. When the Confirm Tag Deletion dialog box appears, click *OK* (**Figure 2.79**). The tag will be deleted from the Tags pane.

✔ Tips

- If you mistakenly delete the wrong tag (it's bound to happen), choose Edit > Undo Delete Tag(s) (Ctrl Z).

- If you have a bunch of tags to delete, you can Shift-click to select adjacent tags; Ctrl-click to select non-adjacent tags.

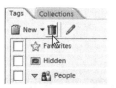

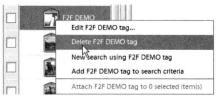

Figure 2.78 To delete a selected tag, click the trash icon in the Tags toolbar (top) or right-click the tag and choose *Delete [Name of] tag* (bottom).

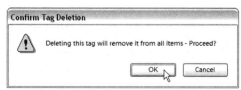

Figure 2.79 Once you click *OK* in the Confirm Tag Deletion dialog box, the tag will be deleted.

DELETING TAGS

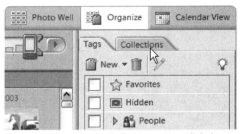

Figure 2.80 To show the Collections pane, click the *Organize* tab, and then click the *Collections* tab.

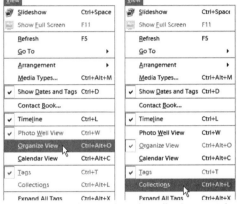

Figure 2.81 You also can show the Collections pane by choosing View > Organize View (Ctrl Alt O) (left) and then choosing View > Collections (Ctrl Alt L) (right).

Working with Collections

Photoshop Album 2 includes a new Collections pane, which makes it much easier to take photos—no matter how they're tagged—and easily rearrange them. You can use it, for example, to create a slideshow or bound book of photos arranged in particular sequence. In fact, you can use a collection to create several versions of such a slideshow or book, each tailored for the recipient or occasion.

The advantage of collections over creations (the only way you could rearrange photos in the previous version) is you can use one collection to build another. Unlike creations, collections are displayed in the Photo Well where you can immediately rearrange the photos while viewing them at any size. In contrast, rearranging a creation's photos requires more steps just to reach the photos.

To show the Collections pane:

◆ In the Photo Well, click the *Organize* tab, and then click the *Collections* tab (**Figure 2.80**). The Collections pane will appear.

Or

◆ In the Menu bar, choose View > Organize View (Ctrl Alt O) (left, **Figure 2.81**) and then choose View > Collections (Ctrl Alt L) (right, **Figure 2.81**). The Collections pane will appear.

Or

◆ Press (Ctrl Alt O), then (Ctrl Alt L), and the Collections pane will appear.

✔ Tip

■ You can close the Collections pane by clicking the *Tags* tab, or you can switch out of the Organize view entirely by clicking the *Photo Well* or *Calendar View* tabs.

To create a collection:

1. With the Collections pane visible, click the *New* button in the Collections toolbar (**Figure 2.82**).

2. When the Create Collection dialog box appears, give the collection a *Name* and describe its purpose in the *Note* field (**Figure 2.83**).

3. Click *OK* to close the dialog box and the new collection will appear in the Collections pane (**Figure 2.84**).

4. Click the Show All button in the Shortcuts bar (**Figure 2.85**) to display all your photos except those with the Hidden tag (see first *Tip*).

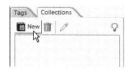

Figure 2.82
To create a collection, click the *New* button in the Collections toolbar.

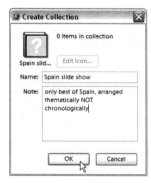

Figure 2.83
Use the Create Collection dialog box to give the collection a *Name* and describe its purpose in the *Note* field.

Figure 2.84
A newly created collection will appear in the Collections pane with a *?* until you add photos.

Figure 2.85
Click the Show All button in the Shortcuts bar to display all your photos.

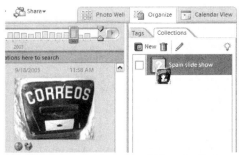

Figure 2.86 Click and drag photo(s) from the Photo Well onto your new collection in the Collections pane.

Figure 2.87
A thumbnail image of the first photo added to the collection will appear in the collection icon.

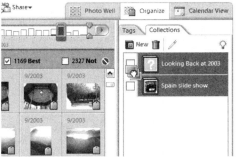

Figure 2.88 To add photos to more than one collection, [Shift]-click to select several collections, then drag selected photos from the Photo Well onto the collection icons.

Figure 2.89
To see which collections any photo belongs to, hold the cursor over the collection icon below the photo in the Photo Well.

5. Select one or more photos in the Photo Well ([Shift]-click to select adjacent photos; [Ctrl]-click to select non-adjacent photos), then drag the selection onto your new collection in the Collections pane (**Figure 2.86**). Release the cursor and the photo(s) will be added to the collection and a collection icon will appear in the Photo Well beneath each added photo. A thumbnail image of the first photo added to the collection also will appear within the collection's bound-book icon (**Figure 2.87**).

6. Continue selecting and adding photos to the collection until you're done. If you want to rearrange the photos in the collection, see page 59.

✔ Tips

■ You can use tags and the Find functions (see page 74) to narrow your selection of photos in the Photo Well before you start adding them to a collection.

■ You can add photos to more than one collection at once: With the Collections pane visible, [Shift]-click to select several collections, then select and drag photos from the Photo Well onto the collection icons (**Figure 2.88**). This is a real time saver if, for example, you want to build several slideshows that contain many of the same photos.

■ You can quickly see which collections any photo belongs to by holding your cursor over the collection icon below the photo in the Photo Well (**Figure 2.89**).

To remove photos from a collection:

◆ With the Collections pane visible, select one or more photos in the Photo Well (⟨Shift⟩-click to select adjacent photos; ⟨Ctrl⟩-click to select non-adjacent photos). Now, right-click the selection and choose *Remove from Collection > [name of individual collection]* (**Figure 2.90**). The photo will be removed from the selected collection.

✔ Tip

■ Do not use the ⟨Delete⟩ key when removing items from a collection because that will remove the photos from your catalog. Thankfully, Photoshop Album will display a dialog box asking if you really want to delete the photos.

To remove an entire collection:

◆ With the Collections pane visible, right-click a collection and choose *Delete [name of] collection* (**Figure 2.91**). The collection will be deleted.

Figure 2.90 To remove a photo from a collection, right-click it in the Photo Well and choose *Remove from Collection > [name of individual collection].*

Figure 2.91 To delete an entire collection, right-click it in the Collections pane and choose *Delete [name of] collection.*

Figure 2.92
To display all the photos in a collection, select the checkbox next to the collection in the Collections pane.

Figure 2.93 A collection of photos will be sequentially numbered in the Photo Well.

Figure 2.94 To rearrange the photos, select them in the Photo Well and drag the selection to its new place in the sequence. A thumbnail image will guide your placement.

Figure 2.95 Release the cursor and the selected photo(s) will move to the insertion point and all the photos will be renumbered.

To rearrange photos in a collection:

1. In the Collections pane, select the checkbox next to the collection you want to work with (**Figure 2.92**). All the photos in that collection will appear in the Photo Well, numbered in sequence (**Figure 2.93**).

2. Select one or more photos in the Photo Well (Shift-click to select adjacent photos; Ctrl-click to select non-adjacent photos), then drag the selection to its new place in the sequence. A thumbnail of the image(s) will guide your placement in the sequence (**Figure 2.94**).

3. Release the cursor and the selected photo(s) will move to the insertion point and all the photos will be renumbered (**Figure 2.95**). Continue selecting and moving photos until you're satisfied with the sequence.

✔ Tip

- You also can rearrange the collection's photos from oldest to newest by right-clicking the collection's name in the Collections pane and choosing *Reorder [name of] collection by date* (**Figure 2.96**).

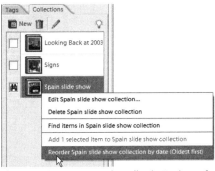

Figure 2.96 To rearrange the collection's photos from oldest to newest, right-click its name in the Collections pane and choose *Reorder [name of] collection by date*.

To change a collection name, note, or icon:

1. In the Collections pane, right-click the collection that you want to change and choose *Edit [name of] collection* (**Figure 2.97**).

2. When the Edit Collection dialog box appears, type in a new *Name* or *Note* (**Figure 2.98**). Or click the *Edit Icon* button to change the thumbnail image. When you are done, click *OK* to close the dialog box and the changes will be applied.

✔ Tip

■ Editing collection names, notes, and icons works exactly like editing tags. For more information, see pages 48–50.

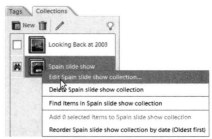

Figure 2.97 To change a collection name, note, or icon, right-click it in the Collections pane and choose *Edit [name of] collection*.

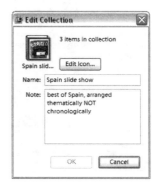

Figure 2.98 Use the Edit Collection dialog box to change a collection's *Name* or *Note*. Or click the *Edit Icon* button to change the thumbnail image.

WORKING WITH CATALOGS

Photoshop Album uses what it calls catalogs, which are really multimedia databases, to keep track of all your photos and their edited variations. Catalogs not only track the images but also all their associated tags, collections, captions, notes, and categories. For the most part, you don't really even need to think about catalogs. Making regular backups of your catalog(s), however, is essential for protecting your photos, should anything ever go wrong. That's why this chapter appears *before* the other chapters that show you how to use many of Photoshop Album's cool features. Be safe by backing up right now and you won't be sorry later.

Backing Up Catalogs

Making a backup catalog can take up to 20 minutes—longer if you have several thousand images and start from scratch. Sure it's slow, but it beats the hours of frustration you could spend if your hard drive ever fails. After all, these catalogs are the digital equivalent of your family's irreplaceable print photo albums: the first thing you'd grab if a fire or flood threatened your home. Unlike with those print albums, however, you can make a *second* set of backup discs to keep somewhere other than your home. In that context, the time spent backing up is a bargain.

To backup your catalog:

1. From the Menu bar, chose File > Backup (**Figure 3.1**).

2. When the *Choose an Action* view of the Burn/Backup dialog box appears, *Backup the Catalog* will already be selected, so click *Next* (**Figure 3.2**).

3. If the Missing Files Check Before Backup dialog box appears, you may have inadvertently moved some of your images and Photoshop Album's catalog has lost track of their location (**Figure 3.3**). (To avoid such problems, see the second and third *Tips* on page 66.) To find the files, click *Reconnect*. Photoshop Album will search for any missing files (**Figure 3.4**). Most of the time, the missing files will be found quickly and you can resume creating a backup catalog as explained in step 5. If Photoshop Album cannot find the files on its own, the Reconnect Missing Files dialog box will appear (**Figure 3.5**). The missing file(s) will be listed in the left-hand pane, along with a thumbnail of the first image selected. The right-hand pane will display the missing image's last known location and a question mark thumbnail.

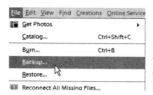

Figure 3.1
To backup or archive your catalog, chose File > Backup.

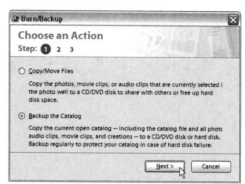

Figure 3.2 When the *Choose an Action* view of the Burn/Backup dialog box appears, *Backup the Catalog* will already be selected, so click *Next*.

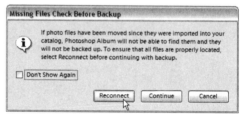

Figure 3.3 If the Missing Files Check Before Backup dialog box appears, Photoshop Album's catalog may have lost track of the location of the image(s), so click *Reconnect*.

Figure 3.4 Photoshop Album will search for any missing files, which it usually finds fairly quickly.

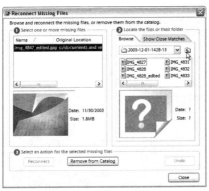

Figure 3.5 Photoshop Album will list the missing files that have been moved in the left-hand pane, above a thumbnail of the first missing file.

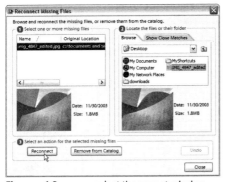

Figure 3.6 Once you select the correct missing folder, the thumbnails in the dialog box will match, and you can click *Reconnect*.

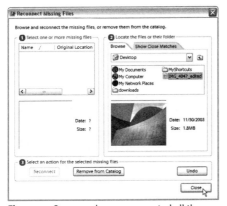

Figure 3.7 Once you have reconnected all the missing files, the left-hand pane will be blank and you can click *Close* to leave the dialog box and resume the backup process.

4. If you don't want Photoshop Album to keep looking for the file (perhaps because you've already deleted it manually), click the *Remove from Catalog* button at the bottom of the Reconnect Missing Files dialog box (**Figure 3.5**). Photoshop Album will purge any references to the file in its catalog. You can then continue with your backup as explained in step 5.

or

If you need to manually search for the missing image, select one or more of the files listed in the left-hand pane (Shift-click to select adjacent photos; Ctrl-click to select non-adjacent photos). Use the navigation icons at the top of the right-hand pane to browse your way to the folder where you suspect the file(s) resides. When you find the correct file, the thumbnail images in both panes will match, and you can click *Reconnect* (**Figure 3.6**). Once you have reconnected all the missing files, the left-hand pane will be blank and you can click *Close* to leave the dialog box (**Figure 3.7**). You can now continue making a backup as explained in the next step.

(continued on next page)

5. When the *Backup Options* view of the Burn/Backup dialog box appears, select *Full Backup* if this is the first time you've backed up the catalog or *Incremental Backup* if you've previously backed up the catalog (**Figure 3.8**). The Incremental Backup will only copy files created or changed since your last backup.

6. When the *Destination Settings* view of the Burn/Backup dialog box appears, scroll through the *Select Destination Drive* list to find the hard drive or CD/DVD burner where you want to create your backup (**Figure 3.9**). If you choose a drive, you'll need to click the dialog box's *Backup Path Browse* button and then use the Browse For Folder dialog box that appears to pick a destination folder (**Figure 3.10**). The first time you choose a burner, Photoshop Album will ask you to insert a blank disc to help it establish the best speed for burning the disc (**Figure 3.11**) before returning you to the *Destination Settings* view of the Burn/Backup dialog box.

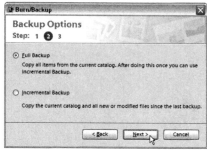

Figure 3.8 In the *Backup Options* view of the Burn/Backup dialog box, select *Full Backup* if this is the first time you've backed up the catalog.

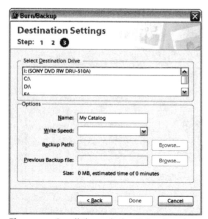

Figure 3.9 Scroll through the *Select Destination Drive* list to find the hard drive or CD/DVD burner you want to use in creating your backup.

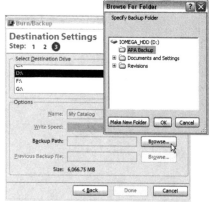

Figure 3.10 If you want to backup to a hard drive, click the *Backup Path Browse* button and then use the Browse For Folder dialog box to pick a destination folder.

Figure 3.11 The first time you use a CD or DVD burner to make a backup, you'll be asked to insert a blank disc to establish the best burning speed.

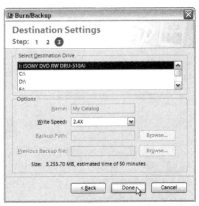

Figure 3.12 Once you've set your destination for the backup, click *Done*.

Figure 3.13 A status bar will track the backup process to your hard drive (top) or disc burner (bottom).

Figure 3.14 Click *OK* to close the dialog box and if you backed up to a hard drive, you're done (top). If you backed up to a CD or DVD (bottom), see the next step for verifying that that the disc burned correctly.

7. Click *Done* to start the backup (**Figure 3.12**). An alert dialog box will appear if the catalog requires more than one disc. Assuming you have enough discs, click *Yes* to proceed. A status bar will track the backup process (**Figure 3.13**) until it's complete (**Figure 3.14**). Click *OK* to close the dialog box and if you backed up to a hard drive, you're done.

8. If you backed up to a disc, there's one last crucial step: verifying that the disc was burned correctly (top, **Figure 3.15**). Click *Verify* and follow the dialog box prompts to test the disc(s). Once the testing is complete, click *OK* to close the dialog box (bottom, **Figure 3.15**). Now you really are done—except for marking your calendar for your next backup.

(continued on next page)

Figure 3.15 Click *Verify* and follow the dialog box prompts to test the disc(s) (top). Once the testing is done, click *OK* to close the dialog box (bottom).

BACKING UP CATALOGS

✔ Tips

- The first time you back up your Photoshop Album catalog, you should always choose *Full Backup*. If you've only added a few photos to the catalog since your last backup, you can choose *Incremental Backup*, which takes less time. It's best to burn a backup to a disc instead of backing up to your hard drive. That way, if your computer fails entirely, you'll still have a copy of the catalog.

- In step 3 to speed Photoshop Album's search (**Figure 3.4**), if you know where the file is, you can click *Browse* to go straight to the Reconnect Missing Files dialog box (**Figure 3.5**).

- In step 3, you won't need to reconnect to files unless Photoshop Album loses track of where they reside. That usually only happens when you manually drag files out of the folders where Photoshop Album stores image files. You can avoid that problem entirely by always using Photoshop Album itself to move files: Select files in the Photo Well, from the Menu bar choose File > Move ([Ctrl] [Shift] [V]), use the Move Selected Items dialog box to navigate to a new folder, and click *OK* to complete the move (**Figure 3.16**).

- Photoshop Album 2 includes an option to have files reconnected automatically, which makes the process a lot easier. From the Menu, choose Edit > Preferences ([Ctrl] [K]) and select *Files* in the left-hand pane of the Preferences dialog box. Then select *Automatically Search for and Reconnect Missing Files*. Click *OK* to close the dialog box (**Figure 3.17**).

- In step 6, by default Photoshop Album names the catalog *My Catalog* (**Figure 3.9**). If you want to call it something else, use the *Name* text window to rename the catalog.

Figure 3.16 To avoid reconnection issues, always move files by selecting files in the Photo Well, choosing File > Move ([Ctrl] [Shift] [V]) (top), and then using the Move Selected Items dialog box to a choose a new destination folder.

Figure 3.17 To have files reconnected automatically, press ([Ctrl] [K]), select *Files* in the left-hand pane of the Preferences dialog box, and check *Automatically Search for and Reconnect Missing Files*.

Figure 3.18 To recover a damaged catalog, create a new catalog, or switch catalogs, start by choosing File > Catalog (Ctrl Shift C).

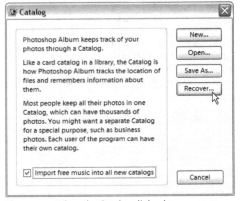

Figure 3.19 When the Catalog dialog box appears, click *Recover*.

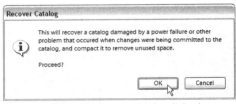

Figure 3.20 When the Recover Catalog dialog box appears, click *OK*.

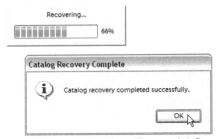

Figure 3.21 A status bar will appear briefly (top) and, if all goes well, a dialog box will announce that the recovery was successful (bottom).

Recovering and Restoring Catalogs

In the unlikely event that anything ever goes wrong with your catalogs, Photoshop Album offers two options: recover and restore. If your computer crashes while you are working in Photoshop Album, use the recover catalog process to attempt to repair any damage. If the recovery fails, you still can try to restore the catalog from your backup catalog, although any changes made since your last backup will not be restored, so use it only as a last resort. You also can use the restore process to retrieve photos from the backup that you may have accidentally deleted from your current catalog.

To recover a catalog

1. From the Menu bar, chose File > Catalog (Ctrl Shift C) (**Figure 3.18**).

2. When the Catalog dialog box appears, click *Recover* (**Figure 3.19**).

3. When the Recover Catalog dialog box appears, click *OK* (**Figure 3.20**). A status bar will appear briefly and then—if all goes well—a dialog box will announce that the recovery was successful (**Figure 3.21**). Click *OK* to close the dialog box and begin working with the recovered catalog. If the recovery fails, see *To restore a catalog* on the next page.

RECOVERING A CATALOG

To restore a catalog

1. If your backup catalog is on a CD or DVD, insert it into your disc drive. If your backup is on another hard drive, make sure it's connected to your computer.

2. From the Menu bar, chose File > Restore.

3. When the Restore dialog box appears, the CD/DVD option is selected by default (**Figure 3.22**). Use the *Select Drive* window to choose a disc drive or, if the backup is on a hard drive, select *Restore from hard disk or other storage volume*. Once you make your selection, click *Restore*.

4. A dialog box will appear asking you to insert any disc from the backup set, if you haven't already done so. Click *Continue* and another dialog box will warn you that this will overwrite your current catalog. If you could not recover the original catalog, click *Yes* to begin the restore process (**Figure 3.23**).

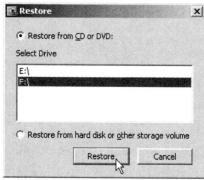

Figure 3.22 When restoring a catalog, the CD/DVD option is selected by default. If the backup is on a hard drive, select *Restore from hard disk or other storage volume* instead.

Figure 3.23 If you could not recover the original catalog, click *Yes* to begin the restore process.

Figure 3.24 A status bar will track the restoration from the first disc (top). If the backup resides on more than one disc, you'll be asked to insert each disc in turn (bottom).

5. Depending on the status of your current catalog, you may see yet another dialog box warning that you are about to over-write files that already exist. Once again, if you could not recover the catalog, click *Yes to All*. A status bar will appear, track-ing the restoration from the first disc (top, **Figure 3.24**).

6. If the backup resides on more than one disc, a dialog box will ask you to insert another disk (bottom, **Figure 3.24**). Click *Continue*, and another status bar will appear, and the dialog box prompts will continue to appear until all the backup discs have been inserted.

7. Once the restoration is completed, the Photo Well will be redrawn. Some items, particularly videos or photo projects (called creations in Photoshop Album), may take a bit longer to reappear. While they are being restored, their places will be marked by an hourglass icon and an hourglass will rotate at the bottom-right corner of the Photo Well.

RESTORING A CATALOG

Making, Switching, or Copying Catalogs

The only limit on the size of a catalog is the capacity of your hard drive. So in most cases, you'll never need to create another catalog in Photoshop Album. That's especially true since the sub-category tags can accomplish many of the same things without the potential confusion of having multiple catalogs. If, however, you have more than one person using Photoshop Album on the same computer or you need a business-only catalog as well, it may be useful to create several catalogs. There are several drawbacks, however. You can only work with one catalog at a time, and photos and tags cannot be moved from one catalog to another.

A copy of a catalog does not copy any of the images stored in the original catalog. It only copies the original's tags and tag organization. However, that can be useful if you or someone else wants to create a new catalog using the tags you've already created.

To create a new catalog:

1. From the Menu bar, chose File > Catalog (⌃Ctrl ⇧Shift C) (**Figure 3.18**).

2. When the Catalog dialog box appears, click *New* (**Figure 3.25**).

3. When the New Catalog dialog box appears, it will include a list of your existing catalogs. Type the name of your new catalog in the *File name* text window and click *Save* (**Figure 3.26**). Photoshop Album will close your previous catalog and display the new, empty catalog, whose timeline will show no imports (**Figure 3.27**). You can now begin importing new photos and building new tags for the catalog.

Figure 3.25 To create a new catalog, click *New* in the Catalog dialog box.

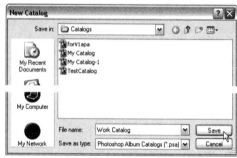

Figure 3.26 Type the name of your new catalog in the *File name* text window and click *Save*.

Figure 3.27 The timeline for the new, empty catalog will show no imports. You can begin importing photos and building new tags for the catalog.

Figure 3.28 To switch catalogs, click *Open* in the Catalog dialog box.

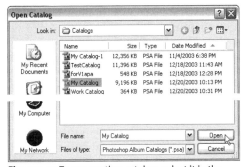

Figure 3.29 To use another catalog, select it in the Open Catalog dialog box and click *Open*.

To switch catalogs:

1. From the Menu bar, chose File > Catalog (Ctrl Shift C) (**Figure 3.18**).

2. When the Catalog dialog box appears, click *Open* (**Figure 3.28**).

3. When the New Catalog or Open Catalog dialog box appears, it will list all your catalogs. Select a catalog, such as your original catalog, and click *Open* (**Figure 3.29**). Your current catalog will close and the selected catalog will open.

To copy a catalog:

1. From the Menu bar, chose File > Catalog (Ctrl Shift C) (**Figure 3.18**).

2. When the Catalog dialog box appears, click *Save As* and navigate to where you want to store the copy.

3. Type a name for the copy in the *File name* text box and click *Save*. The copy will be created and saved.

SWITCHING, COPYING CATALOGS

FINDING PHOTOS

When you import photos into Photoshop Album, the program automatically notes their creation date, import batch, and original location. The program also keeps track of whether the photos came from your digital camera, a scanner, or a folder on your computer. With that detailed information stored within Photoshop Album, you have dozens of ways to track down a particular photo. The timeline and Calendar View provide two powerful tools for finding photos by date. And remember, your ability to find your photos also includes the tags you used to organize your photos in Chapter 2.

Finding Photos Using Tags

Just as Photoshop Album gives you the flexibility to organize your photos with customized tags, it lets you harness the power of those tags to find individual photos or groups of photos. As always, you have several ways to use tags in such searches.

Ways to find photos using tags:

◆ Make sure the Tags pane is visible by clicking the *Organize* tab in the Photo Well and then the *Tags* tab. Now double-click any tag in the pane. Photos with that tag will appear in the Photo Well (**Figure 4.1**).

◆ Make sure the Tags pane is visible by clicking the *Organize* tab in the Photo Well and then the *Tags* tab. Now select the blank box to the left of the tag. Photos with that tag will appear in the Photo Well (**Figure 4.1**).

◆ Make sure the Tags pane is visible by clicking the *Organize* tab in the Photo Well and then the *Tags* tab. Now click-and-drag a tag into the Find bar (the narrow strip just above the Photo Well) (**Figure 4.2**). Photos with that tag will appear in the Photo Well (**Figure 4.1**).

◆ From the Menu bar, choose Find > Items Tagged with and then navigate to the particular tag you want to use (**Figure 4.3**). Photos with that tag will appear in the Photo Well (**Figure 4.1**).

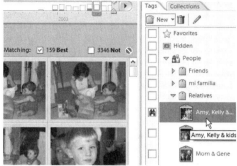

Figure 4.1 Double-click any tag in the Tags pane, and photos with that tag will appear in the Photo Well.

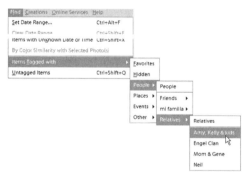

Figure 4.2 To find tagged photos, you also can click-and-drag a tag into the Find bar.

Figure 4.3 A third way to find tagged photos: choose Find > Items Tagged with and then navigate to the particular tag you want used.

Figure 4.4 To cancel a find, click the Show All icon in the Shortcuts bar (top) or click the *Clear* button in the Find bar (bottom).

✔ Tips

- Within the Tags pane, a binoculars icon will appear next to the tag used for the search. The tag also will appear in the Find bar, along with a note on how many items matched that tag and how many items did not (**Figure 4.1**).

- You can also search for photos that have no tags attached by choosing Find > Untagged Items (Ctrl Shift Q).

- To see photos that do not match the chosen tag(s), check *Not* and uncheck *Best* in the Find bar (**Figure 4.1**).

- To find photos tagged Hidden, double-click the Hidden tag in the Tags pane.

Ways to cancel a find:

- Click the Show All icon in the Shortcuts bar (top, **Figure 4.4**). All your photos will reappear in the Photo Well.

- Click the *Clear* button in the Find bar (the narrow strip at the top of the Photo Well) (bottom, **Figure 4.4**). All your photos will reappear in the Photo Well.

- Press the Spacebar and all your photos will reappear in the Photo Well.

Ways to find photos using multiple tags:

Figure 4.5 Photos with either of the two tags appearing in the Find bar will appear in the Photo Well.

◆ Make sure the Tags pane is visible by clicking the *Organize* tab in the Photo Well and then the *Tags* tab, then select the blank box to the left of each tag you want included in the search. Photos tagged with any *one* of those tags will appear in the Photo Well (**Figure 4.5**). The Photo Well will update automatically as you select more tags.

◆ Make sure the Tags pane is visible by clicking the *Organize* tab in the Photo Well and then the *Tags* tab. Now click-and-drag each tag into the Find bar that you want used in the search. As you drag additional tags into the Find bar, photos with those tags will appear in the Photo Well (**Figure 4.5**). The Photo Well will update automatically as you drag more tags to the Find bar. See *Understanding Multiple-Tag Searches* on the next page for more information on how Photoshop Album handles multiple-tag searches.

✔ Tip

■ As you search for photos, selecting and then unselecting tags, you may start finding photos you don't remember seeking. One explanation: A tag hidden from view in the Tags pane remains accidentally selected. From the Menu bar, choose View > Expand All Tags ([Ctrl][Alt][X]) to see if that's the case.

Searching with the Favorites and Hidden Tags

While you can search only for photos marked Favorites, the tag becomes more useful and powerful when you combine it with other tags already applied to your photos. That way, you can quickly see your favorite shots within a particular category or sub-category. Similarly use the Hidden tag with other category and sub-category tags. If you have a project with hundreds of photos which you don't want cluttering up the Photo Well, for example, attach the Hidden tag and they'll be tucked out of sight. Photos tagged as Hidden will not appear even when you click the Show All icon. The only way Hidden photos appear is if you select the checkbox next to the Hidden tag in the Tags pane. You can quickly gauge how many photos have been marked hidden using the timeline (see page 78).

Understanding Multiple-Tag Searches

When making a multiple-tag search, the results will vary depending on whether any of the photos have more than one tag attached. Taking a look at the Find bar shows how this works in some example searches:

◆ In **Figure 4.6**, the Find bar shows *1 Best* match for all three of the selected tags (*_Jim & Lenora, _Kay&Paul*, and *_Ray&Kerry*). The Find bar also shows *114 Close* matches, which means that 114 photos have at least one of the three tags attached.

Figure 4.6 Only one photo matches exactly by having all three tags. Another 114 items are a close match by having at least one of the three tags.

◆ In **Figure 4.7**, the other 114 photos appear after selecting the *114 Close* checkbox in the Find bar. Rolling the cursor over one of those 114 photos in the Photo Well confirms why it's just a close and not exact match: It only has the *_Jim & Lenora* tag attached.

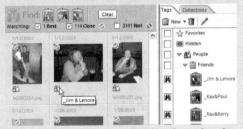

Figure 4.7 Checking the *114 Close* box shows the other photos tagged with at least one of the three tags.

◆ After removing all but one of the three tags originally attached to the photo in **Figure 4.6** (leaving it tagged only with *_Ray&Kerry*), a new search now shows that no photos match all three selected tags. Instead, the Find bar shows *115 Close* matches (**Figure 4.8**).

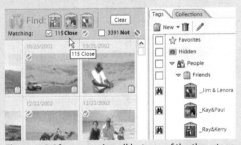

Figure 4.8 After removing all but one of the three tags originally attached to the photo in **Figure 4.6**, a new search shows no photos that match all three selected tags. Instead, the Find bar shows *115 Close* matches.

Finding Photos by Date

At first, the timeline might seem almost dull. But once you learn how to combine it with the Photo Well's sorting ability, you'll find it one of the most effective ways to find photos. While also using dates, the Calendar View offers a more graphical way to help you find those photos immediately. It's also great for special events with set dates, such as birthdays and holidays. Photoshop Album even includes a way to find undated photos.

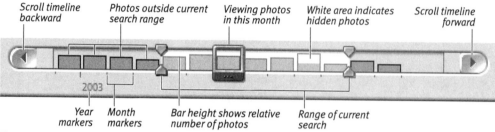

Figure 4.9 The timeline contains enough information to create precise photo searches.

To find photos with the timeline:

1. If the timeline is not visible, from the Menu bar choose View > Timeline (Ctrl L) and the timeline will appear (**Figure 4.9**).

2. To choose how you want the photos sorted, click the Photo Well arrangement pop-up menu in the Options bar (or Ctrl Alt 0 to see the newest photos first, Ctrl Alt 1 to arrange with the oldest first, Ctrl Alt 2 to see by import batch, or Ctrl Alt 3 to see based on folder location). The timeline will change to reflect your choice (**Figure 4.10**).

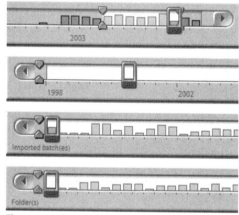

Figure 4.10 The timeline display changes to reflect how you've sorted the Photo Well: newest first (top), oldest first (2nd from top), import batch (2nd from bottom), or folder location (bottom).

Figure 4.11 Click and drag the timeline's endpoints to adjust the date range you want to search.

Figure 4.12 You also can adjust the timeline search by choosing Find > Set Date Range ([Ctrl][Alt][F]) (top) and then using the Set Date Range dialog box's text windows and drop-down menus (bottom).

Figure 4.13 Click any month in the timeline (top) and, depending on how you've set the Photo Well sort order, the first or last photo of that month will appear with a bright green border (bottom).

3. Click and drag the timeline's endpoints to adjust the date range you want to search (**Figure 4.11**). The Photo Well will display the results.

or

From the Menu bar, choose Find > Set Date Range ([Ctrl][Alt][F]) and when the Set Date Range dialog box appears, use the text windows and drop-down menus to define the range you want searched (**Figure 4.12**). Click *OK* and the Photo Well will display the results.

or

Click any month in the timeline and, depending on how you've set the Photo Well sort order, the first or last photo of that month will appear with a bright green border (**Figure 4.13**).

✔ Tip

- Unless you have an exact date you are searching for, clicking and dragging the timeline's endpoints is faster than using the Set Date Range dialog box.

To find tagged photos with the timeline:

1. Click and drag a tag or tags from the Tags pane into the Find bar—just as you did when using tags to find photos. The Photo Well will display only photos with that tag or tags.

2. Now click and drag the timeline's endpoints to adjust the date range for where you want to find specific tagged photos. The results in the Photo Well will update to show the search results.

To find photos with the Calendar View:

1. Click the *Calendar View* tab (top, **Figure 4.14**) and the Calendar View pane will appear and the Photo Well will be arranged based on which of three buttons is selected in the Options bar (**Figures 4.15–4.17**).

 or

 In the Menu bar, choose View > Calendar View (Ctrl Alt C) (bottom, **Figure 4.14**) and the Calendar View pane will appear and the Photo Well will be arranged based on which of three buttons is selected in the Options bar (**Figures 4.15-4.17**).

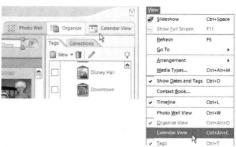

Figure 4.14 To switch to the Calendar View, click the upper-right tab (left) or choose View > Calendar View (Ctrl Alt C) (right).

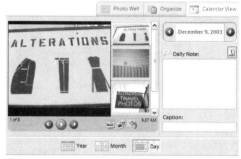

Figure 4.15 By default, the Calendar View displays a single day's worth of photos in the Photo Well with space for a *Daily Note* and *Caption* in the right-hand pane.

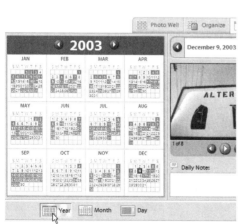

Figure 4.17 By clicking *Year* in the Options bar, the Calendar View's Photo Well will switch to an annual grid with thumbnail images marking each day that photos were shot. Like the Day view, this view's right-hand pane also has room for a *Daily Note* (see Figure 4.15).

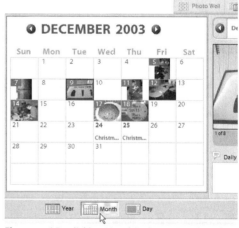

Figure 4.16 By clicking *Month* in the Options bar, the Calendar View's Photo Well will switch to a monthly grid with thumbnail images marking each day that photos were shot. Like the Day view, this view's right-hand pane also has room for a *Daily Note* (see Figure 4.15).

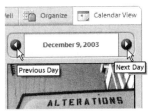

Figure 4.18 To see another day in the calendar, click the back and forward arrows on either side of the listed day. Arrows flanking the month and year displays can be used the same way.

Figure 4.19 If you are working in the month view, you can jump to another date by clicking either the month or year and choosing from the drop-down menus.

2. To see another day, month, or year, click the back and forward arrows on either side of the day, month, or year (**Figure 4.18**), or click the name of the month or year and make a choice from the drop-down menus (**Figure 4.19**).

3. Once you find the desired photo, click the grid-with-arrow icon at the bottom of the Calendar View (**Figure 4.20**) and the photo will be highlighted in the Photo Well with a bright yellow border (**Figure 4.21**).

(continued on next page)

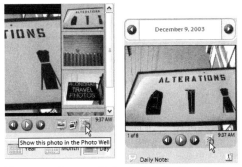

Figure 4.20 Once you find a photo using the calendar features, click the grid-with-arrow icon to locate it within the Photo Well.

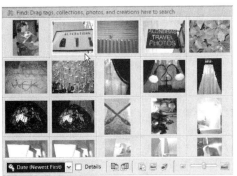

Figure 4.21 Once Photoshop Album locates the photo, it will be highlighted in the Photo Well with a bright yellow border.

✔ Tips

■ In step 2, months or years containing photos will be marked by a small photo icon within the drop-down menu.

■ The new *Daily Note* feature (right, **Figure 4.22**) makes it easy for travelers to describe a whole day's worth of photos during a long trip without having to construct elaborate category/subcategory tags. Days containing such notes are marked in the monthly grid by a small speech balloon icon (left, **Figure 4.22**). (Appearances to the contrary, the speech balloon does not mean the photo has an audio file associated with it.)

To find photos by unknown dates:

◆ From the Menu bar, choose Find > Items with Unknown Date or Time ([Ctrl][Shift][X]). The Photo Well will display all photos with no set date or time.

✔ Tip

■ If you want to add a date or time to any of the photos, see *To change a photo's date or time* on page 36.

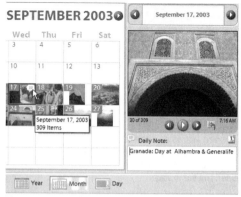

Figure 4.22 Use the *Daily Note* feature (right), to describe a day's worth of photos. Days with such notes are marked in the monthly grid by a small speech balloon icon (left).

Figure 4.23 The extensive Find menu includes just about every imaginable way to find a photo.

Figure 4.24
When the Find by Filename dialog box appears, type in part or all of the name and click *OK*.

Figure 4.25
To find photos by caption or note, choose Find > By Caption or Note (Ctrl Shift J).

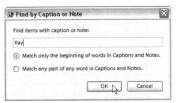

Figure 4.26 When the Find by Caption or Note dialog box appears, type in part or all of the caption or note for the photo you are seeking.

Figure 4.27
The Find bar will list how many photo captions or notes contain matching text, and the first matching photo will appear in the Photo Well.

Other Ways to Find Photos

Given the powers of catalogs within Photoshop Album, it's no surprise that Photoshop Album includes dozens of other ways to find photos (**Figure 4.23**).

To find photos by filename:

1. From the Menu bar, choose Find > By Filename (Ctrl Shift K).

2. When the Find by Filename dialog box appears, type in part or all of the name and click *OK* (**Figure 4.24**). Photos with file names containing the text will appear in the Photo Well.

To find photos by caption or note:

1. From the Menu bar, choose Find > By Caption or Note (Ctrl Shift J) (**Figure 4.25**).

2. When the Find by Caption or Note dialog box appears, type in part or all of the caption or note for the photo you are seeking (**Figure 4.26**). Use the two radio buttons below the text window to fine-tune your search and click *OK*. The Find bar will tell you how many photo captions or notes contain the text, and the first matching photo will appear in the Photo Well (**Figure 4.27**).

✔ Tip

■ Unfortunately you cannot use this method to search for words within a photo's Daily Note (see the second tip on the previous page).

OTHER WAYS TO FIND PHOTOS

To find photos by history:

1. From the Menu bar, choose Find > By History and then make a choice from the drop-down menu (**Figure 4.28**).

2. In this example, choosing *E-mailed to* prompts Photoshop Album to show a list of recipients of emailed photos (**Figure 4.29**). (For more information on emailing from Photoshop Album, see 136.)

3. Make a selection in the dialog box and click *OK*. The results will appear in the Photo Well and the Find bar will display details of the search (**Figure 4.30**).

✔ Tip

■ As you can see in the drop-down menu in **Figure 4.28**, Photoshop Album automatically tracks virtually everything you might do with a photo: import or export it, print or share it, use it in a Photoshop Album project (called a creation) or on the Web, to name just a few of the choices.

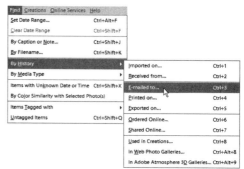

Figure 4.28 To find photos by history, choose Find > By History and then make a choice from the drop-down menu.

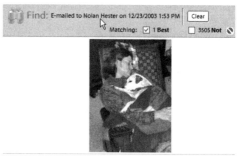

Figure 4.29 Choosing *E-mailed to* prompts Photoshop Album to show a list of recipients of emailed photos.

Figure 4.30 All photos mailed to the selected email recipient will appear in the Photo Well.

Figure 4.31 To find photos by media type, choose Find > By Media Type and then make a choice from the drop-down menu.

Figure 4.32 To find photos similar in color to those selected in the Photo Well, first choose Find > By Color Similarity with Selected Photo(s).

Figure 4.33 Photos with colors similar to the selected photos will then appear in the Photo Well.

Figure 4.34 To see a broader range of photos with colors similar to your original selection(s), select the Find bar's *Close* box.

To find photos by media type:

◆ From the Menu bar, choose Find > By Media Type and then make a choice from the drop-down menu (**Figure 4.31**). The Photo Well will display all the items matching your drop-down menu choice.

To find photos of similar color:

1. In the Photo Well, select a photo or photos where the predominant colors come close to the colors you want to find in other photos (such as the orange of autumn leaves).

2. Drag the selected photo(s) into the Find bar, or choose Find > By Color Similarity with Selected Photo(s) (**Figure 4.32**). Photos with colors similar to the selected photos will appear in the Photo Well (**Figure 4.33**).

✔ Tips

■ The initial search results in the Photo Well may include only very close color matches. To see a broader range of photos with colors similar to your original selection(s), select the Find bar's Close box (**Figure 4.34**).

■ The similar-color search can be particularly useful for finding duplicate images since the colors will be virtually the same. The Close option also can be a great tool for slideshow sequencing where you may want to break up the chronological order with clusters of, say, yellow flowers or autumn leaves.

OTHER WAYS TO FIND PHOTOS

EDITING PHOTOS

Today's digital cameras are very good at nailing the correct exposure for a photo. Many also include automatic red eye reduction features, further boosting your chances of getting a near perfect shot. But when you inevitably need to make some fixes to a photo—or simply want to crop it a bit tighter—Photoshop Album includes a number of easy-to-use photo editing controls.

To safeguard your original photo, Photoshop Album makes all your editing changes to a copy of that photo (named *originalname_edited*) and saves it in the same folder as the original. From that point on, Photoshop Album automatically opens the edited version whenever you select the original photo in the Photo Well. If you are not happy with the results of any edits, you can always revert back to the original photo.

To select photos to fix:

◆ In the Photo Well, click the photo you want to edit. ([Shift]-click to select adjacent photos or [Ctrl]-click to select non-adjacent photos.)

To rotate photos:

1. In the Photo Well, select the photo(s) you want to rotate.

2. Click the Rotate Left or Rotate Right icon in the Options bar (**Figure 5.1**). After the Rotating Photos dialog box briefly appears, the Photo Well display will change to reflect the rotation (**Figure 5.2**).

 or

 Right-click any of the selected photos, and choose Rotate Right or Rotate Left from the pop-up menu (**Figure 5.3**).

 or

 From the Menu bar, choose Edit > Rotate Right or Rotate Left.

✔ Tips

■ It's common to rotate your photos within the Photo Well since it lets you quickly see which ones need reorienting in a new import batch. However, you can also rotate a single photo by choosing Edit > Fix Photo and then clicking the Rotate Left or Rotate Right icons within the Fix Photo dialog box. That may be more convenient if you are making all your corrections to a single photo at the same time.

■ Despite what the submenus say, there are no keyboard commands to rotate photos right or left.

Figure 5.1
To rotate a selected photo, click the Rotate Left or Rotate Right icon in the Options bar.

Figure 5.2 The Rotating Photos dialog box will appear briefly (left) before the Photo Well displays the rotated photo (right).

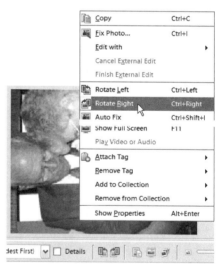

Figure 5.3 You also can right-click any selected photo and choose Rotate Right or Rotate Left from the pop-up menu.

SELECTING, ROTATING PHOTOS

Window view tabs *Preview window* *Edit options* *Help button*

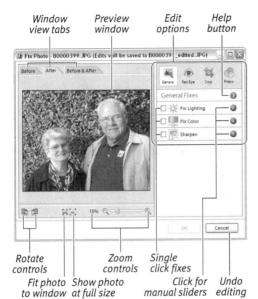

Rotate controls *Zoom controls* *Single click fixes*

Fit photo to window *Show photo at full size* *Click for manual sliders* *Undo editing*

Figure 5.4 Most of your photo editing will occur using the Fix Photo dialog box.

Figure 5.5 To open the Fix Photo dialog box, click the Fix icon in the Shortcuts bar (top), or right-click the photo and choose Fix Photo from the pop-up menu (bottom).

Figure 5.6 In the Quick Guide, click the *Fix* icon or tab (top) and then any of six editing icons (bottom).

Using the Fix Photo Dialog Box

With the exception of rotating photos within the Photo Well, you'll do virtually all your photo editing using the Fix Photo dialog box (**Figure 5.4**).

To open the Fix Photo dialog box:

1. In the Photo Well, select a single photo to edit.

2. Click the Fix icon in the Shortcuts bar (top, **Figure 5.5**). The selected photo will appear in the Fix Photo dialog box (**Figure 5.4**).

 or

 Right-click the photo and choose Fix Photo from the pop-up menu (bottom, **Figure 5.5**). The selected photo will appear in the Fix Photo dialog box (**Figure 5.4**).

 or

 Use the Menu bar to choose Edit > Fix Photo ([Ctrl][I]). The selected photo will appear in the Fix Photo dialog box (**Figure 5.4**).

 or

 Double-click a photo in the Photo Well and when it appears in the single view, double-click it again. The selected photo will appear in the Fix Photo dialog box (**Figure 5.4**).

 or

 If you are using the Quick Guide, click the Fix icon or tab and when the Fix Photos panel appears, click any of its six icons (**Figure 5.6**). The selected photo will appear in the Fix Photo dialog box (**Figure 5.4**).

To zoom in or out while fixing photos:

◆ In the Fix Photo dialog box, click the +
or – magnifying glass icons in the bottom
toolbar or click the Fit to Window icon
([Ctrl][0]) or the Actual Pixels icon
([Alt][Ctrl][0]) (**Figure 5.7**).

To compare before and after photo fixes:

◆ In the Fix Photo dialog box, click the
Before tab to see the photo before any
fixes (the *After* tab is selected by default).
Or click the *Before & After* tab to com-
pare the effects of your fixes as you make
them (**Figure 5.8**).

✔ Tip

■ Photoshop Album 2 improves upon the
original program by letting you use the
Actual Pixels icon to zoom in on your
Original and *After* views of the photo
(**Figure 5.9**). You will find this very
useful in comparing the effects of subtle
fixes. Dragging the horizontal or vertical
scroll bars for either picture will move
both views in tandem, making compar-
isons easy. Click the Fit to Window
icon to return to the non-zoomed view
of the photo.

Figure 5.7 To zoom in or out while fixing
photos, click the + or – icons or click the Fit
to Window icon ([Ctrl][0]) or the Actual
Pixels icon ([Alt][Ctrl][0]).

Figure 5.8 To compare before and after photo fixes,
click the *Before & After* tab.

Figure 5.9
By using the
Actual Pixels
icon to zoom
in on your
Original and
After views, you
can easily com-
pare the effects
of subtle fixes.

Ways to undo or redo photo fixes:

◆ If you want to undo all your fixes and close the Fix Photo dialog box, click *Cancel* in the bottom-right of the Fix Photo dialog box, then choose *No* in the alert dialog box that appears. The photo will revert to how it appeared before the fixes were applied.

◆ If you have already closed the Fix Photo dialog box but are not happy with the results when the photo reappears in the Photo Well, right-click the photo and choose *Revert to Original* in the short-cuts menu, or from the Menu bar, choose Edit > Fix Photo ([Ctrl][Z]).

◆ If you undo a fix and then decide you want to make the fix after all, from the Menu bar choose Edit > Redo Fix Photo ([Ctrl][Y]).

✔ Tip

■ You can see what the original photo looked like without clicking the *Cancel* button by clicking the *Before* tab in the Fix Photo dialog box (**Figure 5.8**).

UNDOING, REDOING PHOTO FIXES

To crop a photo:

1. Select the photo, open the Fix Photo dialog box, and click the *Crop* icon in the upper-right of the dialog box. A dashed rectangle will appear within your photo, indicating how the crop marks will be applied (**Figure 5.10**).

2. Use the *Aspect Ratio* drop-down menu in the *Crop Photo* panel to choose what width-to-height proportions you want to use in applying the crop. The crop marks will change to reflect those proportions.

3. Click and drag inside the dashed rectangle to reposition the crop marks, or click and drag a corner of the dashed rectangle to shrink or expand the area to be cropped (**Figure 5.11**).

4. Once you've adjusted the crop marks to your satisfaction, click *Apply* in the Crop Photo panel. The results of the crop will appear in the left side of the Fix Photo dialog box (**Figure 5.12**). If you plan to make other fixes to the photo, leave the dialog box open. If the crop is the only fix you want to make, click *OK* to close the Fix Photo dialog box and return to the Photo Well.

✔ Tips

- In step 2, the *Aspect Ratio* drop-down menu only controls the width-to-height proportions of the crop, while the overall size is controlled by your adjustments in step 3.

- If you are unhappy with the results and want to start over, click the *Undo* button at the bottom right of the Fix Photo dialog box (**Figure 5.10**).

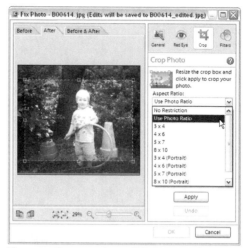

Figure 5.10 To crop a photo, click *Crop* near the upper-right of the dialog box and use the *Aspect Ratio* drop-down menu to choose your crop proportions.

Figure 5.11 The initial crop marks (left) can be repositioned (middle) and resized (right).

Figure 5.12 The results of your crop will appear in the Fix Photo dialog box.

CROPPING A PHOTO

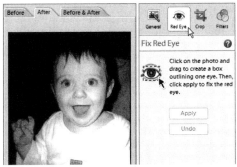

Figure 5.13 To remove red eye, click the *Red Eye* icon in the upper-right of the Fix Photo dialog box.

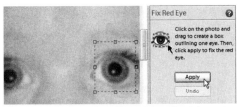

Figure 5.14 Once you've adjusted the effect's boundaries to zero in on a single eye, click *Apply*.

To remove red eye:

1. Select the photo with red eye, open the Fix Photo dialog box, and click the *Red Eye* icon in the upper-right of the dialog box (**Figure 5.13**). Within your photo, drag the cursor to select just one eye where red needs to be removed.

2. Use the zoom controls to enlarge the photo enough so that you can then accurately click and drag the dashed rectangle to include just the red pupil plus some of the surrounding iris.

3. Click *Apply* in the *Fix Red Eye* panel (**Figure 5.14**). The results will appear in the left side of the Fix Photo dialog box. If you plan to make other fixes to the photo, leave the dialog box open, otherwise click *OK* to close the Fix Photo dialog box and return to the Photo Well.

✔ Tips

- Confine the dashed rectangle to a single eye. Be sure, however, to include some of the surrounding iris as well, since that seems to help Photoshop Album identify the red area in the pupil more accurately. In some cases, you may want to zoom in by 400–800 percent to isolate one eye at a time before applying the effect (**Figure 5.14**).

- You may need to apply red eye removal several times to get rid of all the red.

- If you are unhappy with the results, click the *Undo* button at the bottom right of the Fix Photo dialog box (**Figure 5.14**).

- Many cameras have a red eye reduction flash, which uses a blinking light to shrink the subject's pupil before firing the main flash. You also can reduce red eye problems by taking pictures at a slight angle to your subject's eyes.

REMOVING RED EYE

To change photos to black-and-white or sepia:

1. Select a photo, open the Fix Photo dialog box, and click the *Filters* icon in the upper-right of the dialog box.

2. Within the *Apply Filters* panel, select either *Black & White* or *Sepia* to change the photo's tone (**Figure 5.15**). If you apply one effect and want to try the other instead, select *None* to return to the original color version before applying the other choice.

3. If you plan to make other fixes to the photo, leave the dialog box open, otherwise click *OK* to close the Fix Photo dialog box and return to the Photo Well.

✔ Tip

- Once you convert the photo to a black-and-white or sepia version, you may need to adjust the lighting. Do this by clicking the *General* icon in the Fix Photo dialog box. For more information, see *Manually Adjusting Photos* on page 100.

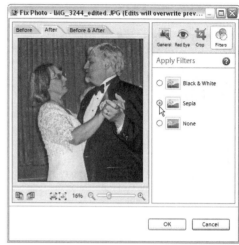

Figure 5.15 Within the *Apply Filters* panel, select either *Black & White* or *Sepia* to change the photo's tone.

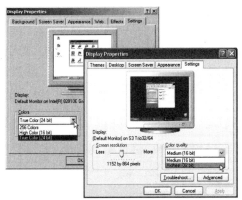

Figure 5.16 To calibrate a CRT monitor, make sure the *Colors* or *Color quality* panel is set to *High Color (16 bit)*, *True Color (24 bit)*, or *Highest (32 bit)*.

Figure 5.17 No matter which version of Windows you are running, look inside the Control Panel folder to start Adobe Gamma.

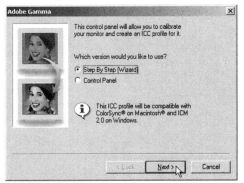

Figure 5.18 When the Adobe Gamma dialog box appears, choose *Step By Step (Wizard)*.

Calibrating Your Monitor

Before you begin correcting the brightness, contrast, and color of your photos, you need to make sure your computer monitor is calibrated to accurately display photos. You can only calibrate a monitor with a CRT (a cathode ray tube, much like that of a television). LCD monitors (the Liquid Crystal Displays in laptops and thin desktop monitors) cannot be calibrated accurately since your angle of view changes their apparent brightness and color. While calibrating takes a little time, it will make it much easier to produce prints that match what you see onscreen. Even with a calibrated monitor, you may need to tweak the settings once you see your prints. Pay attention to your results and you'll learn how to judge what works best.

To calibrate a CRT monitor:

1. Make sure your CRT monitor has been on for at least 30 minutes, then from the Start menu, choose Control Panel > Display. When the Display Properties dialog box appears, click the *Settings* tab and make sure that the *Colors* or *Color quality* panel is set to *True Color (24 bit)*, or *Highest (32 bit)* (**Figure 5.16**). Click *OK* to close the dialog box.

2. Click the Start button and, depending on which version of Windows you are using, choose Settings > Control Panel >Adobe Gamma (top) or Control Panel >Adobe Gamma (**Figure 5.17**). When the Adobe Gamma dialog box appears, choose *Step By Step (Wizard)* and click *Next* (**Figure 5.18**).

(continued on next page)

3. The Adobe Gamma step-by-step guide will walk you through a series of dialog boxes to check your monitor's brightness, contrast, and color balance (white point). When you're done, the guide will ask you to save the settings as a file, which Photoshop Album will use as its reference point (**Figure 5.19**).

✔ Tip

■ Many monitors now are self-calibrating, which makes this step unnecessary. Check your display's manual to make sure.

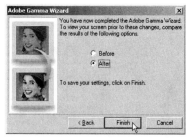

Figure 5.19 The Adobe Gamma program (top) asks you to save the settings (bottom), which Photoshop Album will use as its reference.

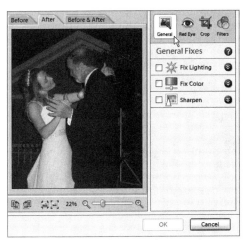

Figure 5.20 To fix the lighting or color, or to sharpen a photo, first click the *General* icon in the upper-right of the Fix Photo dialog box.

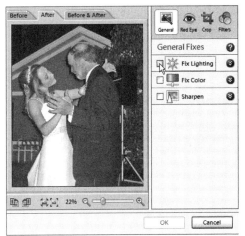

Figure 5.21 To automatically adjust an underlit photo, select *Fix Lighting* in the *General Fixes* panel.

Fixing Photos Automatically

Photoshop Album uses some powerful behind-the-scenes mathematical formulas that can automatically analyze and fix many of your photos in a single click. Grouped together in the Fix Photo dialog box as *General Fixes*, these three checkboxes let you fix a photo's lighting, color, or focus with a minimum of fuss. The Fix Lighting choice balances a photo's brightness and contrast. The Fix Color choice adjusts the photo's saturation and overall tint (what's called color temperature). The Sharpen choice finds the edges of objects in the photo and boosts the contrast along those edges based on the photo's original resolution. By knowing the resolution, Photoshop Album avoids oversharpening, which can make objects seem pasted onto the background. Be aware that these three fixes do not always work perfectly, so you may sometimes need to adjust the settings manually (see page 100) And if you are using a monitor with a CRT, remember to calibrate the monitor first (see previous page).

To automatically fix single photos:

1. Select a photo, open the Fix Photo dialog box, and click the *General* icon in the upper-right of the dialog box (**Figure 5.20**).

2. Within the *General Fixes* panel, select *one* of the top two checkboxes: *Fix Lighting* or *Fix Color*, depending on the problem you're trying to solve. In **Figure 5.20**, the photo is underlit so *Fix Lighting* is selected to lighten the overall scene (**Figure 5.21**).

(continued on next page)

FIXING PHOTOS AUTOMATICALLY

3. Based on the results in step 2, you may then also want to select *Fix Color* (**Figure 5.22**).

4. Based on the results in step 3, you may then want to select *Sharpen*. Once you're satisfied with the results, click *OK* to close the Fix Photo dialog box and return to the Photo Well.

✔ Tip

■ If you're not quite happy with the results, you can manually tweak the automatic results by clicking the double-chevron buttons to expose the manual sliders for any of the three settings (**Figure 5.23**). For more information on using the slider, see 100.

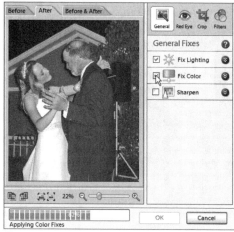

Figure 5.22 To automatically adjust a photo's colors, select *Fix Color* in the *General Fixes* panel.

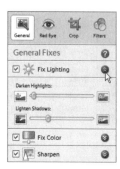

Figure 5.23
You can manually tweak the automatic results by clicking the double-chevron button to expose the manual sliders for any of the three settings in the *General Fixes* panel.

FIXING PHOTOS AUTOMATICALLY

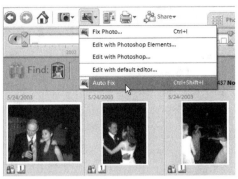

Figure 5.24 To automatically fix multiple photos, select them in the Photo Well and then click the *Fix* button in the Shortcuts bar and choose Auto Fix in the drop-down menu ($\boxed{\text{Ctrl}}$ $\boxed{\text{Shift}}$ $\boxed{\text{I}}$).

Figure 5.25
A status bar in the Auto Fix Photos dialog box will track the program's progress in fixing the photos.

Figure 5.26 You also can fix the selected photos by choosing Edit > Auto Fix Selected Photos (top) or right-clicking them and choosing *Auto Fix Selected Photos* in the shortcuts menu (bottom).

To automatically fix multiple photos:

1. Select the photos in the Photo Well that you want to fix ($\boxed{\text{Shift}}$-click to select adjacent photos; $\boxed{\text{Ctrl}}$-click to select non-adjacent photos).

2. Click the *Fix* button in the Shortcuts bar and choose Auto Fix in the drop-down menu ($\boxed{\text{Ctrl}}$ $\boxed{\text{Shift}}$ $\boxed{\text{I}}$) (**Figure 5.24**). When the Auto Fix Photos dialog box appears, a status bar will track the fixing of the photos (**Figure 5.25**). Once the dialog box closes, the fixed photos will appear in the Photo Well.

 or

 From the Menu bar, choose Edit > Auto Fix Selected Photos ($\boxed{\text{Ctrl}}$ $\boxed{\text{Shift}}$ $\boxed{\text{I}}$) (top, **Figure 5.26**). When the Auto Fix Photos dialog box appears, a status bar will track the fixing of the photos (**Figure 5.25**). Once the dialog box closes, the fixed photos will appear in the Photo Well.

 or

 Right-click any of the selected photos and choose *Auto Fix Selected Photos* in the shortcuts menu ($\boxed{\text{Ctrl}}$ $\boxed{\text{Shift}}$ $\boxed{\text{I}}$) (bottom, **Figure 5.26**). When the Auto Fix Photos dialog box appears, a status bar will track the fixing of the photos (**Figure 5.25**). Once the dialog box closes, the fixed photos will appear in the Photo Well.

✔ Tip

- If you're not happy with the results, from the Menu bar choose Edit > Undo Auto Fix ($\boxed{\text{Ctrl}}$ $\boxed{\text{Z}}$). You can then either apply single-click fixes to each photo individually or manually adjust each one.

Manually Adjusting Photos

Sometimes automatic fixes do not give you the necessary degree of control that's needed. With such photos, manually adjusting the controls in the Fix Photo dialog box may give you better results. Just remember: Even small changes using the controls can have a big effect on a photo's appearance, so apply the effects in tiny steps until you gain experience.

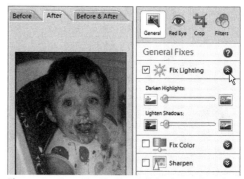

Figure 5.27 Open the Fix Photo dialog box, select the *Fix Lighting* checkbox, and click the double-chevron button to reveal the manual sliders.

To manually adjust highlights and shadows:

1. Select the photo that you want to fix, open the Fix Photo dialog box, select the *Fix Lighting* checkbox, and then click the double-chevron button to reveal the manual sliders (**Figure 5.27**).

2. Depending on the photo, click and drag the *Darken Highlights* and/or *Lighten Shadows* sliders a bit at a time to change the photo (**Figure 5.28**). Move the *Darken Highlights* slider to the right to make the photo's brightest areas darker; move the *Lighten Shadows* slider to the right to make the darkest areas lighter. Click the *Before & After* tab to evaluate your adjustments.

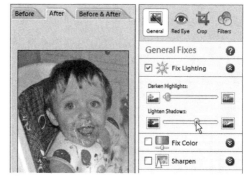

Figure 5.28 Depending on the photo, click and drag the *Darken Highlights* and/or *Lighten Shadows* sliders a bit at a time to change the photo's lighting.

3. To make other manual adjustments, leave the dialog box open, otherwise click *OK* to close the Fix Photo dialog box and return to the Photo Well with the changes saved.

✔ Tip

- Because Photoshop Album has no live preview, you may have to wait a moment for the adjustments to be applied to the photo.

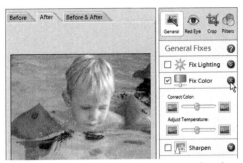

Figure 5.29 Open the Fix Photo dialog box, select the *Fix Color* checkbox, and click the double-chevron button to reveal the manual sliders.

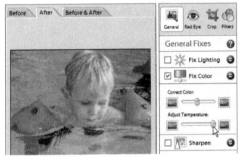

Figure 5.30 Depending on the photo, click and drag the *Correct Color* and/or *Adjust Temperature* sliders a bit at a time to change the photo's color.

To manually adjust color:

1. Select the photo that you want to fix, open the Fix Photo dialog box, select the *Fix Color* checkbox, and then click the double-chevron button to reveal the manual sliders (**Figure 5.29**).

2. Depending on the photo, click and drag the *Correct Color* and/or *Adjust Temperature* sliders a bit at a time to change the photo (**Figure 5.30**). Move the *Correct Color* slider to the right to increase the amount of color correction applied. Move the *Adjust Temperature* slider to the right to make the photo color warmer (more red and yellow), or to the left to make it cooler (more blue). Click the *Before & After* tab to evaluate your adjustments.

3. To make other manual adjustments, leave the dialog box open, otherwise click *OK* to close the Fix Photo dialog box and return to the Photo Well with the changes saved.

MANUALLY ADJUSTING COLOR

Using Other Photo Edit Programs

As versatile as Photoshop Album is, its abilities to fix photos focus on the most basic tasks. If you want to apply a special effects filter, for example, you'll need to use another photo editing program. Fortunately, Photoshop Album makes that easy by creating an automatic link to Photoshop Elements if it is installed anywhere on your computer. Officially priced at $99 and often on sale for less, Photoshop Elements offers all but a few of the professional-level features of Adobe's $650 Photoshop program. You'll find its look and feel familiar after learning Photoshop Album. If you prefer to use another graphics program, it's easy to set that program to launch instead or set up Photoshop Album so that the other program is available for occasional use. Photoshop Album automatically knows if you have the full-featured Photoshop on your computer and also will offer it as a choice for editing within Photoshop Album's Edit menu. You only need to change the editing preference if you want to use a program other than these two Adobe programs.

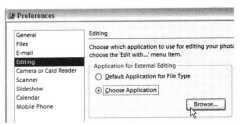

Figure 5.31 To set a non-Adobe program as your external photo editing preference, select *Editing* in the left-hand list, select *Choose Application* in the right-hand panel, and use the *Browse* button to navigate to that application.

Figure 5.32 Your preferred external editing program will appear at the bottom of the submenu when you choose Edit > Edit with > [name of the application].

To change the external editing preference:

1. From the Menu bar, choose Edit > Preferences (Ctrl K).

2. When the Preferences dialog box appears, choose *Editing* in the left-hand list, then use the *Application for External Editing* pane (**Figure 5.31**). By default, *Default Application for File Type* is selected, which will be Photoshop Elements if it is installed on your computer. To choose a non-Adobe program, select *Choose Application* and use the *Browse* button to navigate to that application.

3. When you've selected the application, click *OK* and its name will appear at the bottom of the submenu when you use the Menu bar to choose Edit > Edit with > [name of the application] (**Figure 5.32**).

CHANGING THE EXTERNAL EDITING PREFERENCES

To edit with another application:

1. In the Photo Well, right-click the photo you want to fix and choose Edit with > [name of the application] (**Figure 5.33**). You also can use the Menu bar to choose Edit > Edit with > [name of the application] or click the Fix icon in the Shortcuts bar and choose *Edit with [name of the application]* from the drop-down menu.

2. Just before the other editing program opens, you'll see an alert dialog box warning that you cannot make changes in Photoshop Album while the photo is open in the other application. If fact, if you try to switch back to Photoshop Album while the photo is open in the other application, you'll see that the photo is locked (**Figure 5.34**).

3. The external application you selected will launch and display the selected photo, where you can then make changes (**Figure 5.35**).

(continued on next page)

Figure 5.33 To edit with another application, right-click the photo you want to fix and choose Edit with > and then make a choice in the submenu.

Figure 5.34 Photoshop Album locks the photo as long as you are editing with your other editing application.

Figure 5.35 The photo opens in Photoshop Elements, where you can make fixes not possible in Photoshop Album.

Figure 5.36 Changes made in the other editing program will appear in the Photoshop Album Photo Well.

Figure 5.37 If you don't want to save the changes, right-click the photo and choose Revert to Original.

4. When you're done making changes in the external application, save the changes without changing the file's name (see first *Tip* below), and close the photo.

5. Switch back to Photoshop Album and the changes made in the other program will now appear in the Photo Well (**Figure 5.36**). If you don't want to save the changes within Photoshop Album, from the Menu bar, choose Edit > Undo External Edit (Ctrl Z) or right-click the photo and from the drop-down menu choose, Revert to Original (**Figure 5.37**).

✔ Tips

- If you are using Photoshop or Photoshop Elements as your external editing program, you can rename the photo in step 5 without problems. But if you rename the file using any other editing program, Photoshop Album will not be able to automatically display the changed photo.

- Since keeping track of all your photos is one of the main reasons for using Photoshop Album, make a habit of using Photoshop Album to launch any external editing application, as described above. That way, Photoshop Album will be able to keep straight where all original and edited copies of your photos are stored. If you open a photo directly in another editing application, Photoshop Album will not record the changes and this makes it much more difficult to keep your photos organized.

(continued on next page)

EDITING WITH ANOTHER APPLICATION

- If you are using Photoshop or Photoshop Elements as your external editor and choose to rename the photo, when you return to Photoshop Album a Save As dialog box will appear (**Figure 5.38**). Rename the photo, click *Save* and Photoshop Album gives you the choice of saving the file as an edited copy of the original or as a new file. (If you used Photoshop, you'll also have the choice of saving an edited copy in Photoshop's .psd format.) In general, choose to save it as an edited copy of the original file (the default), which will make it easier to find the edited or original photo later on.

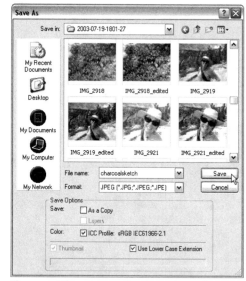

Figure 5.38 If you rename the photo when using Photoshop or Photoshop Elements, a Save As dialog box will appear when you switch back to Photoshop Album.

CREATING PROJECTS

Before digital photography came along, you had three ways to show your photos: as single prints, album collections, or silent slideshows showing one photo at a time. Using your computer and Photoshop Album, those single prints now can be saved in many formats; the albums stored on paper, your hard drive, or a CD; and that slideshow can include background music, professional transitions, and multiple photos onscreen. It's no wonder that digital cameras rank among today's best-selling electronic items.

Make sure you have already cropped and edited your photos before diving into creating projects with them. You'll also save time if you add captions to those photos beforehand. By the way, Photoshop Album calls such projects "creations," but I'll just call them projects.

Using the Creations Wizard

No matter what kind of project you are creating, the Creations Wizard walks you through the same basic steps: picking a project template, selecting its style, customizing the details, previewing the results, and then saving (what Photoshop Album calls publishing) the final project. *To use the Creations Wizard* walks you through that basic process and then the subsequent tasks in this section explain things unique to each particular type of project.

To use the Creations Wizard:

1. In the Shortcuts bar, click the Create button or, from the Menu bar, choose Creations > New or any of the specific creation types offered in the menu (**Figure 6.1**).

2. When the Creations Wizard dialog box appears, the *Album* template will be selected by default in the left-hand panel. Select the type of project you want to create in the left-hand panel and click *Next* (**Figure 6.2**).

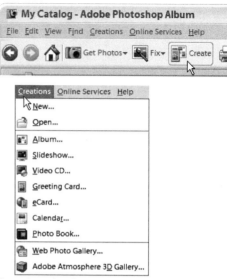

Figure 6.1 In the Shortcuts bar, click the Create button (top) or, from the Menu bar, choose Creations > New or any of the specific creation types offered in the menu (bottom).

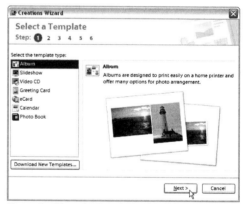

Figure 6.2 When the Creations Wizard dialog box appears, select in the left-hand list the type of project you want to create and click *Next*.

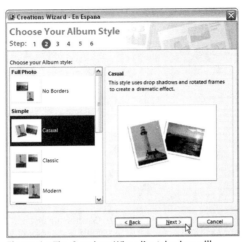

Figure 6.3 The Creations Wizard's style view will include a variety of choices, with a preview and text description of each.

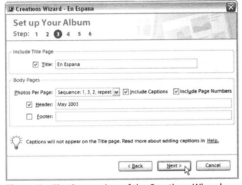

Figure 6.4 The Set up view of the Creations Wizard includes lots of ways to tailor your project with such items as titles, headers, and footers.

3. Depending on which project you're creating, when the style view of the Creations Wizard appears, the left-hand style list will include a variety of choices, any one of which you can click to see a preview and a text description in the right-hand panel (**Figure 6.3**). After selecting one you like, click *Next*.

4. Depending on which project you're creating, the Set up view of the Creations Wizard will include different ways to tailor your project with such items as titles, headers and footers, message greetings, or even background music (**Figure 6.4**). For details on these choices, see the individual projects on pages 114–127. Once you're done customizing the project, click *Next*.

5. When the *Pick Your Photos* view of the Creations Wizard appears, the main window initially will contain no photos. Click the *Add Photos* button to gather the photos you want to use in the creation (**Figure 6.5**).

(continued on next page)

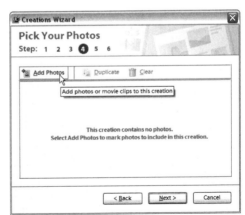

Figure 6.5 Click the *Add Photos* button to gather photos for the initially blank *Pick Your Photos* view.

<div style="text-align: right">**USING THE CREATIONS WIZARD**</div>

6. When the Add Photos to Creation dialog box appears, the *Photo Well* is selected by default within the *Add Photos From* panel (**Figure 6.6**). By scrolling through the right-hand window, you can select any of the photos in the Photo Well to add to your creation. However, you also can select other choices in the *Add Photos From* panel (**Figure 6.7**): the *Entire Catalog* (the Photo Well plus all Hidden photos), any *Collection* or *Tag* by using the nearby drop-down menus, or any photos previously marked as *Favorites* or *Hidden*. Once you make your choices, click the *Add to Creation* button and the added photos will be numbered sequentially in the *Pick Your Photos* view of the Creations Wizard when it reappears (**Figure 6.8**).

7. You can click and drag any of the photos to rearrange their sequence. For details on reordering the photos, see *To rearrange photos in a collection* on page 59. Once you're satisfied with the order (and you can click the *Add Photos* button at any time to bring in more photos), click *OK* to close the Add Photos to Creation dialog box and then click *Next*.

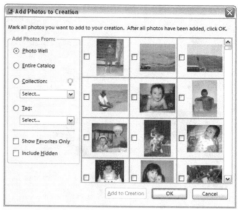

Figure 6.6 In the Add Photos to Creation dialog box, the *Photo Well* is selected by default. Scroll through the right-hand window to select photos you want to add.

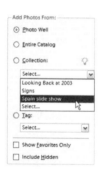

Figure 6.7
The *Add Photos From* panel uses radio buttons and drop-down menus to give you quick access to all, or just some, of your photos.

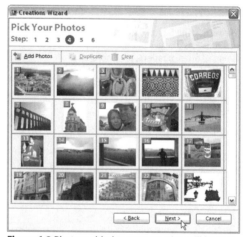

Figure 6.8 Photos added to your creation will be numbered sequentially in the *Pick Your Photos* view. Click and drag any photo to rearrange the order.

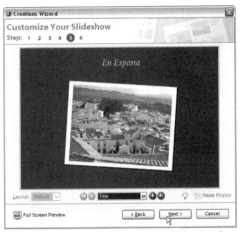

Figure 6.9 The Creations Wizard's Customize view lets you check every project page by clicking the buttons below the first page or by clicking the *Full Screen Preview* button.

Figure 6.10 Move to any step of the Creations Wizard by clicking one of the *Step* numbers or the *Back* and *Next* buttons.

Figure 6.11 Click the red X in the control panel to close the full-screen preview of your project.

8. When the Customize view of the Creations Wizard appears (**Figure 6.9**), the project's title page will be displayed, giving you a chance to check that the right photo, title wording, and layout style are being used. To see the layout and photos for every page, click either the video-style buttons below the first page, the drop-down menu in the middle of the buttons, or the *Full Screen Preview* button in the lower-left corner.

9. If during the preview you see something you want to change, you can navigate to the necessary step in the Creations Wizard by clicking one of the dialog box's *Step* numbers or the *Back* and *Next* buttons (**Figure 6.10**). If you are running a full-screen preview, click the red X in the preview screen's control panel (**Figure 6.11**), which will then let you use the *Step* numbers or *Back* and *Next* buttons in the Creations Wizard.

(continued on next page)

10. Once you are happy with all the project's elements, click *Next* in the Creations Wizard.

11. When the Publish view of the Creations Wizard appears, you can take one of two routes (**Figure 6.12**). If you want to immediately share the project with others, you can click any of the five choices in the *Output Options* panel. But in most cases, you should instead immediately save the project by clicking *Done*. A dialog box will appear briefly telling you that your creation is completed, which will then be saved at the top of the Photo Well with a special creation icon in the upper right (**Figure 6.13**). Once it's saved, you can then share it with others in a variety of forms. For details, see *Sharing Photos* on page 131.

Figure 6.12 When the Publish view of the Creations Wizard appears, click *Done* to save your project.

Figure 6.13 The saved project will appear at the top of the Photo Well with a special icon.

✔ Tips

- Every couple of weeks you may want to click *Download New Templates* in the lower-left corner of the *Select a Template* view of the Creations Wizard (**Figure 6.2**) to see if Adobe has added any new templates to the Creations Wizard.

- While you cannot directly select the font used for the titles, captions, and other labels in step 3, different fonts are used in the styles listed in **Figure 6.3**, so take a close look at each style in the right-hand panel preview.

- Use Ctrl A to automatically select every photo in the right-hand panel of the Add Photos to Creation dialog box (**Figure 6.6**). By combining this keyboard command with careful use of tags or collections in the left-hand *Add Photos From* panel, you can avoid much of the tedium of individually selecting photo checkboxes.

- In step 11, the Creations Wizard by default uses your project's title as the name of the saved project file. If you want to save the project using another, perhaps more descriptive name, uncheck *Use Title for Name* and type your choice in the *Name* text window (**Figure 6.12**).

USING THE CREATIONS WIZARD

Creating a Photo Album

Photoshop Album frees you from the tedium of arranging individual photos on pages. There are no sticky corner holders to mess with, no labels to apply, not even acetate sleeves to load. By choosing from a variety of stylish album templates, you can concentrate on using your photos to tell stories and revive memories.

To create a photo album:

1. From the Menu bar, choose Creations > Album.

2. When the *Choose Your Slideshow Style* view of the Creations Wizard appears, you'll have a variety of styles to choose from (**Figure 6.14**). The left-hand choices can be previewed in the right-hand panel. After selecting one you like, click *Next*.

3. When the *Set up Your Album* view of the Creations Wizard appears (**Figure 6.15**), you can add a *Title* (which only appears on the album's first page), decide how many photos should appear on each page, whether to *Include Captions* and *Include Page Numbers*, and whether to create a *Header* and/or *Footer*. The *Photos Per Page* drop-down menu even includes some sequence choices to vary the layout from page to page (**Figure 6.16**). Once you've made your choices, click *Next*.

Figure 6.14 Album templates make it easy to create professional-looking projects in a variety of styles.

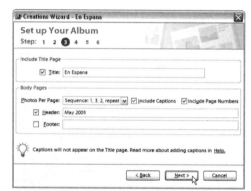

Figure 6.15 Use the *Set up Your Album* view to add a title, set the number of photos per page, and include captions.

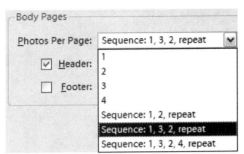

Figure 6.16 The *Photos Per Page* drop-down menu includes choices to vary the layout from page to page.

4. When the *Pick Your Photos* view appears, you'll find that it works identically to the process described in steps 5–7 of *To use the Creations Wizard* on pages 109–110.

5. When the *Customize Your Album* view of the Creations Wizard appears, the album's title page will be displayed, giving you a chance to check that the right photo, title wording, and layout style are being used. To see the layout and photos for all your album pages, click either the video-style buttons below the first page, the drop-down menu in the middle of the buttons, or the *Full Screen Preview* button in the lower-left corner of the Creations Wizard.

6. If you want to change something you noticed during the preview, see step 9 of *To use the Creations Wizard* on page 111.

7. Once you are happy with all the album's elements, click *Next* in the Creations Wizard.

8. When the *Publish Your Album* view of the Creations Wizard appears, save the project by clicking *Done*, which will place the saved project at the top of the Photo Well. Once it's saved, you can then share it with others. For details, see *Sharing Photos* on page 131.

Creating Slideshows

With computer-generated slideshows there's no need for a bulky projector or darkened room. Instead, a sequence of photos can be viewed on your computer screen—or shared with someone else by sending them an email or CD of the slideshow. Photoshop Album helps you set the photo sequence, create transitions between photos at a pace you dictate, and, if you like, add music or spoken audio. You also have the option of watching a slideshow on a TV if you create a Video CD, which can be watched using a DVD player. The growing popularity of DVD players means you may be able to share your slideshow with relatives who don't even own a computer.

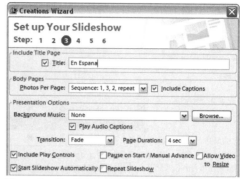

Figure 6.17 Use the *Set up Your Slideshow* view to set a title, the number of photos per slide, and special effects like background music and transitions.

To create a slideshow:

1. From the Menu bar, choose Creations > Slideshow.

2. When the *Choose Your Slideshow Style* view of the Creations Wizard appears, select a style in the left-hand list and click *Next*.

3. When the *Set up Your Slideshow* view of the Creations Wizard appears, you have various options organized under three panels—*Include Title Page*, *Body Pages*, and *Presentation Options* (**Figure 6.17**). In the *Include Title Page* panel, if you check *Title*, you can type into the text window up to 30 characters for the first photo of your slideshow. The title will replace any existing caption in the slideshow.

4. Use the *Body Pages* panel to set the *Photos Per Page* drop-down menu, which includes choices to vary the number of photos used in each *slide* (the slideshow equivalent of a page) (**Figure 6.16**). If you want to show each photo's existing caption, check *Include Captions*.

Figure 6.18 The *Background Music* drop-down menu lists recent sound clips and copyright-free music. Or click *Browse* to find other music on your computer.

Figure 6.19
The *Transition* drop-down menu lets you control the segue from slide to slide.

5. Use the *Presentation Options* panel to set the *Background Music* played during the slideshow. The drop-down menu includes some copyright-free music, plus any sound clips you've used in other Photoshop Album projects (**Figure 6.18**). To use another sound, click *Browse* to navigate to other music. Or select *Play Audio Captions* if you've already attached remarks or music to the individual photos. Use the *Transition* drop-down menu if you want to smoothly segue from slide to slide (**Figure 6.19**), then use the *Page Duration* drop-down menu to set how many seconds (2, 4, or 10) each slide should appear onscreen. Two seconds is brisk; 10 seconds fits the pace of a lecture.

6. Across the bottom of the *Presentation Options* panel you'll find five checkboxes that let you fine-tune the slideshow:
 - ▲ **Include Play Controls.** Select if you want the screen to include controls like those in **Figure 6.11**.
 - ▲ **Pause on Start/Manual Advance.** Select if you want each slide to stay onscreen until you click to advance.
 - ▲ **Allow Video to Resize.** Do not select this unless you are using photos containing at least 5 megapixels, since it will enlarge your photo to fill the screen and may introduce some fuzziness.
 - ▲ **Start Slideshow Automatically.** Select to show the first photo at full screen and then show the rest of the slides without prompting.
 - ▲ **Repeat Slideshow.** Select for continual display, a good option for an unattended show for passersby.

(continued on next page)

7. Once you've set up all the options you need, click *Next* at the bottom of the Creations Wizard. When the *Pick Your Photos* view of the Creations Wizard appears, you'll find that it works identically to the process described in steps 5–7 of *To use the Creations Wizard* on pages 109–110.

8. When the *Customize Your Slideshow* view of the Creations Wizard appears, you can see the layout and photos for every slide by clicking the video-style buttons below the first slide, the drop-down menu in the middle of the buttons, or the *Full Screen Preview* button. To change anything in the slideshow, see step 9 of *To use the Creations Wizard* on page 111.

9. Once you are happy with all the project's settings, click *Next* in the Creations Wizard, and when the *Publish Your Slideshow* view of the Creations Wizard appears, click *Done* to save the project. For details on sharing the slideshow, see *Sharing Photos* on page 131.

✔ Tip

- Feel free to play around with the various transitions in step 5 under the *Customize Your Slideshow* view (**Figure 6.19**). If you've ever used a program like Microsoft PowerPoint, you'll recognize such choices as Dissolve or Fade, which are better choices for a slideshow than the distractions of Box In, Box Out, or Random.

Figure 6.20 To create a slideshow on a video CD, choose Creations > Video CD.

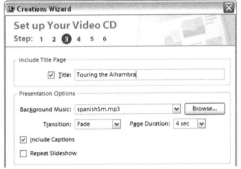

Figure 6.21 The *Set up Your Video CD* view offers choices that mix features found in photo albums and slideshows.

To create a slideshow on a video CD:

1. From the Menu bar, choose Creations > Video CD (**Figure 6.20**).

2. When the *Choose Your Slideshow Style* view of the Creations Wizard appears, select a style in the left-hand list and click *Next*.

3. When the *Set up Your Video CD* view of the Creations Wizard appears (**Figure 6.21**), if you check *Title* in the *Include Title Page* panel, you can type into the text window up to 30 characters that will appear with the first photo of your slideshow. Use the *Presentation Options* panel to set the *Background Music* that will be played during the slideshow. For details, see step 5 of *To create a slideshow* on page 117.

4. Once you've set the options, click *Next* at the bottom of the Creations Wizard to reach the *Pick Your Photos* view of the Creations Wizard. The main window initially will contain no photos. Click the *Add Photos* button to gather the photos you want to use. For more information on adding photos, see step 6 of *To use the Creations Wizard* on page 110. Once you're done adding photos, click *Next*.

5. When the *Customize Your Video CD* view of the Creations Wizard appears, you can see the layout and photos for every screen by clicking the video-style buttons below the first screen, the drop-down menu in the middle of the buttons, or the *Full Screen Preview* button. If you want to change anything, see step 9 of *To use the Creations Wizard* on page 111.

6. Once you are happy with all the settings, click *Next* in the Creations Wizard, and when the *Publish Your Video CD* view of the Creations Wizard appears, click *Done* to save the project. For details on sharing the slideshow by burning a CD, see *Sharing Photos* on page 131.

CREATING A SLIDESHOW ON A VIDEO CD

119

Creating Greeting Cards and eCards

The Creations Wizard shows you how to create two types of cards: traditional print greeting cards or their digital equivalent, which Photoshop Album calls "eCards," for viewing in email or on a CD.

To create a greeting card:

1. Select a single photo in the Photo Well, and from the Menu bar, choose Creations > Greeting Card (**Figure 6.22**).

2. When the *Choose Your Greeting Card Style* view of the Creations Wizard appears, select a style in the left-hand list and click *Next*.

3. When the *Set up Your Greeting Card* view of the Creations Wizard appears (**Figure 6.23**), use the *Title* text window to type up to 30 characters that will appear on the front of the card beside or below the photo. Use the *Greeting* text window to type up to 30 characters that appear at the top inside the card. The *Message* will appear below the greeting text inside the card and can include up to 150 characters. Once you're done, click *Next*.

Figure 6.22
To create a greeting card, choose Creations > Greeting Card.

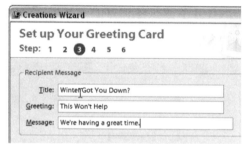

Figure 6.23 The title will appear on the front of the card with the photo, while the greeting and message will appear inside the card.

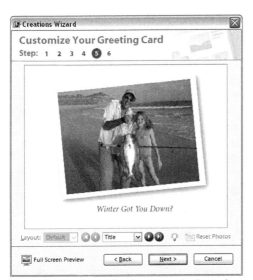

Figure 6.24 The Customize view shows the front of the card. To check the inside, click the forward button or the *Full Screen Preview* button.

4. When the *Pick Your Photos* view of the Creations Wizard appears, the main window already will contain the single photo selected in step 1. Click *Next*.

5. When the *Customize Your Greeting Card* view of the Creations Wizard appears, the front of the card will be displayed (**Figure 6.24**). To check the card's inside, click the forward button below the first page or click the *Full Screen Preview*. If you want to change anything, see step 9 of *To use the Creations Wizard* on page 111.

6. Once you are happy with the card's settings, click *Next*. When the *Publish Your Greeting Card* view of the Creations Wizard appears, save the project by clicking *Done*, which will place the saved project at the top of the Photo Well. Once it's saved, you can then print it to share it with others. For details on various printing options, see *Sharing Photos* on page 131.

✔ **Tip**

■ If you add more than a single photo in step 4, Photoshop Album will use the first photo and ignore the rest.

CREATING GREETING CARDS

To create an eCard:

1. Select a single photo in the Photo Well, and from the Menu bar, choose Creations > eCard (**Figure 6.25**).

2. When the *Choose Your eCard Style* view of the Creations Wizard appears, select a style in the left-hand list and click *Next*.

3. When the *Set up Your eCard* view of the Creations Wizard appears (**Figure 6.26**), use the *Title* text window to type up to 30 characters that will appear on the front of the card beside or below the photo. Use the *Greeting* text window to type up to 30 characters that appear at the top inside the card. The *Message* will appear below the greeting text inside the card and can include up to 150 characters. Type your name in the *Signature* text window.

4. Use the *Presentation Options* panel to set the *Background Music* that will be played while the card is onscreen. For details on the other choices, see steps 5 and 6 of *To create a slideshow* on page 117. Once you have set the custom settings, click *Next*. When the *Pick Your Photos* view of the Creations Wizard appears, the main window already will contain the single photo selected in step 1. Click *Next*.

Figure 6.25
To create an electronic greeting card, choose Creations > eCard.

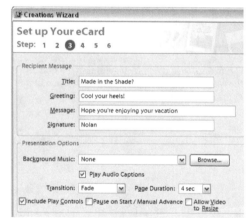

Figure 6.26 The eCard set up choices are similar to those of the printed greeting card.

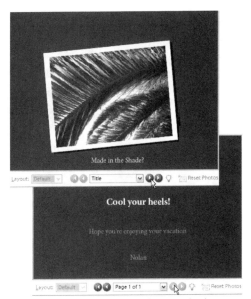

Figure 6.27 The Customize view lets you check your eCard's first screen (top) and second screen (bottom).

5. When the *Customize Your eCard* view of the Creations Wizard appears, the front of the card will be displayed. To check the card's inside, click the forward button below the first page (**Figure 6.27**). If you want to change anything, see step 9 of *To use the Creations Wizard* on page 111.

6. Once you are happy with the card's settings, click *Next*. When the *Publish Your Greeting Card* view of the Creations Wizard appears, save the project by clicking *Done*, which will place the saved project at the top of the Photo Well. Once it's saved, you can then print it to share it with others. For details on various printing options, see *Sharing Photos* on page 131.

✔ Tip

- If you add more than a single photo in step 4, Photoshop Album will use the first photo and ignore the rest.

Creating Photo Calendars

Because they sit out for everyone to see every day, calendars are great for showing off your favorite photos. Unlike store-bought calendars, you can create a calendar for as many, or as few, months as you like. Photoshop Album includes templates for a variety of styles (**Figure 6.28**).

To create a photo calendar:

1. From the Menu bar, choose Creations > Calendar (**Figure 6.29**).

2. When the *Choose Your Calendar Style* view of the Creations Wizard appears, select a style in the left-hand list, take a look at the preview in the right-hand panel, and once you find one you like, click *Next*.

3. When the *Set up Your Calendar* view of the Creations Wizard appears (**Figure 6.30**), you can add a *Title* (which only appears on the calendar's front page without a month) and set the calendar's range using the month and year drop-down menus. Check *Include Captions* if you want them to appear with each month's photo. Once you've made your choices, click *Next*.

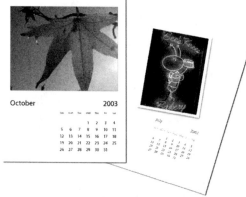

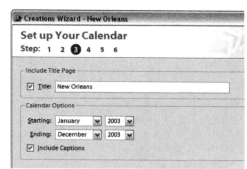

Figure 6.28 Photo calendars can be made in various styles and let you show off your favorite photos.

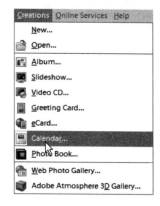

Figure 6.29 To create a calendar, choose Creations > Calendar.

Figure 6.30 Use the Set up view to put a title on the cover, plus set the calendar's time range.

4. When the *Pick Your Photos* view of the Creations Wizard appears, the main window initially will contain no photos (unless you selected some in the Photo Well before step 1). Click the *Add Photos* button to gather the photos you want to use. For more information on adding photos, see step 6 of *To use the Creations Wizard* on page 110. Once you're done adding photos, click *Next*.

5. When the *Customize Your Calendar* view of the Creations Wizard appears, the title page of your first month will be displayed. To check the rest of the months, click the forward button below the first page, the drop-down menu in the middle of the buttons, or the *Full Screen Preview* button in the lower-left corner of the Creations Wizard. If you want to change anything in the calendar, see step 9 of *To use the Creations Wizard* on page 111.

6. Once you are happy with all the settings, click *Next* in the Creations Wizard, and when the *Publish Your Calendar* view of the Creations Wizard appears, click *Done*. The saved project will appear at the top of the Photo Well. Once it's saved, you can then share it with others. For details on all the choices, which go beyond simply printing it, see *Sharing Photos* on page 131.

Creating a Bound Photo Book

There's nothing like a bound book to give your digital photos some real-world heft. Not only does a professionally bound book look good, it's a sure-fire gift for anyone who doesn't want to sit at a computer to see family and friends.

To create a bound photo book:

1. From the Menu bar, choose Creations > Photo Book (**Figure 6.31**).

2. When the *Choose Your Photo Book Style* view of the Creations Wizard appears, select a style in the left-hand list to see a preview, text description, and cost estimate in the right-hand panel (**Figure 6.32**). After selecting one you like, click *Next*.

3. When the *Set up Your Photo Book* view of the Creations Wizard appears (**Figure 6.33**), you can add a *Title*, *Subtitle*, and *Author* to appear on the book's cover; a *Header* and *Footer* to appear on every page except the cover; and whether to include captions and page numbers (see second *Tip* below). Once you've made your choices, click *Next*. When the *Pick Your Photos* view of the Creations Wizard appears, the main window initially will contain no photos (unless you selected some in the Photo Well before step 1). Click the *Add Photos* button to gather the photos you want to use. For more information on adding photos, see step 6 of *To use the Creations Wizard* on page 110. Once you're done adding photos, click *Next*.

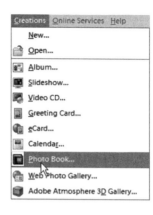

Figure 6.31
To create a bound book of photos, choose Creations > Photo Book.

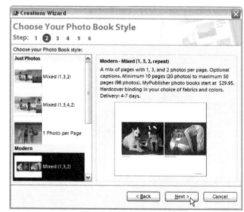

Figure 6.32 The Photo Book style view of the Creations Wizard includes a cost estimate for each photo book style, as well as a preview and description of the style.

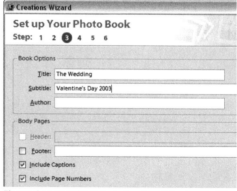

Figure 6.33 Use the Set up view to set the book's title, subtitle, author, headers and footers, page numbers, and captions.

CREATING A BOUND PHOTO BOOK

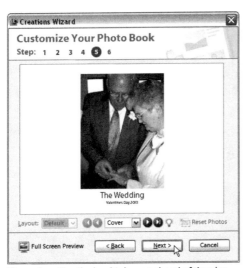

Figure 6.34 See the book's layout ahead of time by using the video-style buttons or the *Full Screen Preview* button.

4. When the *Customize Your Photo Book* view of the Creations Wizard appears, the book's cover will be displayed, giving you a chance to check that the right photo, title wording, and layout style are being used (**Figure 6.34**). To see the layout and photos for all the book pages, click either the video-style buttons below the first page, make a selection from the drop-down menu in the middle of the buttons, or click the *Full Screen Preview* button. If you need to change anything, see steps 6 and 7 of *To use the Creations Wizard* on page 110.

5. Once you are happy with the book's design and settings, click *Next* in the Creations Wizard, and when the *Publish Your Photo Book* view appears, click *Done* to save the book. For details on getting the book printed, see *Using Online Photo Services* on page 134.

✔ Tips

■ Unlike some other projects where the number of photos per page is set in the Customize view, that aspect of photo books is set by the style you choose in step 2.

■ The *Just Photos* choices in the *Choose Your Photo Style* view of the Creations Wizard do not include captions. For that reason, the *Include Captions* choice will be unavailable in the *Set up Your Photo Book* view (**Figure 6.33**).

Finding and Opening Saved Projects

As you create and then save more and more projects, it can become harder to find them amid all the other items in the Photo Well. However, Photoshop Album makes it easy to find them and then open them for viewing or editing.

To find saved projects:

◆ From the Menu bar, choose Find > By Media Type > Creations (Alt 4) (**Figure 6.35**). The Photo Well will then display only projects, each marked with an icon in the upper-right corner (**Figure 6.36**).

✔ Tips

■ Just as with single photos, you can sort projects by using the rearrangement menu in the Options bar at the bottom of the Photo Well.

■ To quickly identify individual projects, right-click a project in the Photo Well and choose *Show Properties* from the short-cuts menu (Alt Enter) (left, **Figure 6.37**). The name of the selected project will appear in the *General* view of the Properties dialog box (right, **Figure 6.37**).

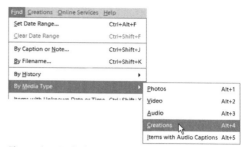

Figure 6.35 To find saved projects, choose Find > By Media Type > Creations.

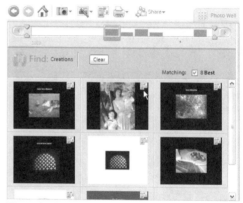

Figure 6.36 Creations in the Photo Well display a special icon in the upper-right corner.

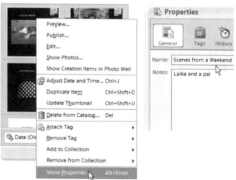

Figure 6.37 To identify individual projects, right-click one in the Photo Well and choose *Show Properties* from the shortcuts menu (Alt Enter) (left). Its name and notes, if you included any, will appear in the *General* view of the Properties dialog box (right).

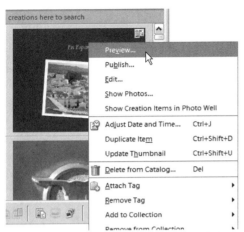

Figure 6.38 To jump to a project's Customize window, right-click the photo and choose Preview.

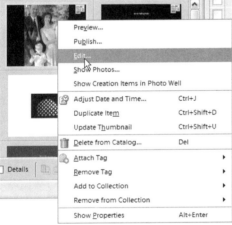

Figure 6.39 To jump to a project's Set up window, right-click the photo and choose Edit.

To open saved projects:

◆ Double-click any project in the Photo Well and it will be displayed in the Customize view of the Creations Wizard. From there you can preview any page or edit the project.

◆ Right-click any project in the Photo Well and from the pop-up menu choose Preview or Edit (**Figures 6.38–6.39**). If you choose Preview, the project will be displayed in the Customize view of the Creations Wizard. If you choose Edit, the project will be displayed in the Set up view of the Creations Wizard. From either view, you then can preview any page or edit the project.

OPENING SAVED PROJECTS

SHARING PHOTOS

Figure 7.1 Photoshop Album automatically alerts you if you try to make a print larger than the image will support.

The payoff for all your organizing, editing, and inspired project work comes when you can show off the photos. With Photoshop Album you have lots of ways to do exactly that: print out your own photos or have an online photo service do it; email photos as single shots or sequenced slideshows; burn a multimedia CD or DVD, or even send them to a mobile camera phone, PDA, or home TiVo unit.

How big is big enough?

Some digital photographers love to debate the fine points of how to get the best prints. Rather than dive into the nitty gritty of resolution and pixel counts, however, I'll keep it simple: The more pixels captured by the camera, the bigger the print can be and still look sharp. Photoshop Album makes it even simpler: It will automatically display a dialog box to alert you if you attempt to make a print larger than the image will support (**Figure 7.1**).

Such alerts might initially confuse you. A photo looks great on your 17-inch monitor, so why won't it look just as good as an 11-by-14-inch print? The short answer is that monitors use light; printers use dots of ink, which no matter how tiny tend to highlight the fuzziness.

Some rules of thumb: a 2-megapixel camera will produce a tack sharp 4-by-6-inch print and an acceptable 8-by-10 print but anything larger will be fuzzy. A 3.2-megapixel camera will produce a professional-grade 5-by-7-inch print and an acceptable 8-by-10-inch print. But for tack-sharp, professional-grade 8-by-10 prints, use a 4-megapixel or higher camera. As always, there are exceptions: You may be willing to overlook less than perfect results in that favorite low-resolution photo of your nephew. If you want to check a selected photo's resolution, open its Properties dialog box (Alt Enter) and check the *Size* at the bottom of the *General* view (**Figure 7.2**).

Finally, check your camera's manual to set the image resolution at its maximum. If you only need to email a photo, Photoshop Album will automatically toss out the extra detail. It's true that you won't be able to store as many images on your memory card. But if you don't capture image detail in the first place, even the most sophisticated software cannot put it back afterward. Considering that memory cards are reusable, they're still cheaper than film, so buy a bigger card or several of them. If you'd like to learn more about the behind-the-scenes details of digital photography, you can visit the *Digital Photography Review's* nicely illustrated online glossary: www.dpreview.com/learn/.

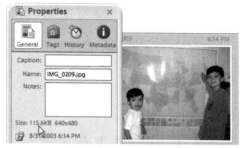

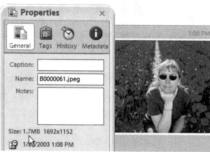

Figure 7.2 To check a photo's resolution, open its Properties dialog box (Alt Enter) and check the *Size*. While fine for email, the top 115KB photo is too small to print. The bottom 1.7MB photo would work well as a 4-by-6 inch print.

Using Photos on Your Desktop

While it may lack the scope of a big project, using an image of your own for your desktop pattern is a perennially popular way to share photos, even if it's just with your office colleagues. It's so easy to do, you can pick a different photo every day if you like.

To turn a photo into your desktop picture:

1. In the Photo Well, select the photo you want to use.

2. From the Menu bar, choose Edit > Set as Desktop Wallpaper (Ctrl Shift W) or right-click the photo and choose *Set as Desktop Wallpaper* in the shortcuts menu. The selected photo will immediately appear as the background image of your computer's desktop.

✔ Tip

■ Depending on which version of Windows you are using, reset the desktop back to its original pattern by choosing Start > Settings > Control Panel > Display, or Start > Control Panel > Display. When the Display or Display Properties dialog box appears, click the *Background* or *Desktop* tab and pick a pattern from the scroll-down list. Click *OK* to close the dialog box.

Using Online Photo Services

The online photo services bundled into Photoshop Album give you quick access to lab-grade photo prints, Web-based photo galleries, and professionally bound photo books. Creating and ordering them is easy, thanks to step-by-step guides built into the program. You can set up accounts with several online photo services or just one. While each online photo service has a slightly different set of steps for placing orders, all guide you through the process. Most of the online photo services offer first-time-user discounts, so you may want to try several and compare the results.

Figure 7.3
To set up online photo services, choose Online Services > Manage Accounts.

To set up online photo services:

1. Open your computer's connection to the Internet, then from the Menu bar, choose Online Services > Manage Accounts (**Figure 7.3**). A progress bar will briefly appear as the list of current services is downloaded.

2. When the Create or Modify Online Service Accounts dialog box appears, make sure the *Choose a Service* drop-down menu is set to *All Service Types*. Choose a service from the list and click *Select* (**Figure 7.4**).

 A progress bar will briefly appear as you are connected to the selected online photo provider.

 A welcome screen will appear to guide you through setting up an account (**Figure 7.5**).

Figure 7.4 Choose a service from the list and click *Select*.

Figure 7.5 A welcome screen will appear to guide you through setting up an online photo service account.

Figure 7.6 Once you have set up an account, you can reach it directly from the Online Services menu.

Figure 7.7 Photoshop Album keeps track of new online photo services (top) and when your list is current (bottom).

Figure 7.8
You can manually check for new online services by choosing Online Services > Check for New Services.

Figure 7.9 To actually see which new services have been added, you must click the Online Services menu: before the update (top) and after the addition of PhotoAccess (bottom).

3. Once you have set up an account, Photoshop Album makes it easy to reach the service directly from the Online Services menu (**Figure 7.6**). If you don't want to order photos just yet, disconnect from the service. You can then return to step 1 to set up another online photo service or, if you have a dial-up connection, disconnect from the Internet as well.

✔ Tips

- In step 1, if Adobe has added new online photo providers since you last used the online services, an alert dialog box will appear (top, **Figure 7.7**). Any new service will be listed in the Create or Modify Online Service Accounts dialog box, where you can select it as described in step 2.

- You can manually check for new online services anytime by choosing Online Services > Check for New Services (**Figure 7.8**). A dialog box will appear telling you either that new services have been added or that your services are current (bottom, **Figure 7.7**). Unfortunately, no dialog box appears to tell which new services have been added. Instead, the new service is automatically added to the appropriate Online Services submenu (**Figure 7.9**).

USING ONLINE PHOTO SERVICES

Emailing Photos and Projects

If you have ever emailed photos to friends or relatives, you probably wrestled with one of the bedeviling details of digital photos: do you send the original or create a fast-to-download version? Do you give the smaller version another name or modify the existing name to signify that it's an email version? How do you keep track of both versions? Again, Photoshop Album makes this sort of problem disappear by handling the naming and tracking behind the scenes.

While you can always manually enter an email address for any photo you're sending out, the Contact Book offers an easier option. Using it, you can create a list of email contacts, which you can tap whenever you email photos. You can even use the contact book to create groups of contacts interested in particular photos. You can, for example, create a group of your softball teammates, to whom you can easily send photos of the last game. You do not have to think of these groups ahead of time; Photoshop Album lets you create groups as you need them. Photoshop Album also automatically keeps track of which photos you have sent to different people.

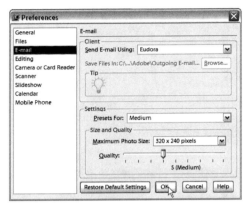

Figure 7.10 In the Preferences dialog box, select *E-mail* in the left-hand list and the *E-mail* panel will appear on the right.

Figure 7.11 To change where email attachments are stored, choose *Other (save to disk)* in the drop-down menu, then click *Browse* to reach your preferred folder.

To set email preferences:

1. From the Menu bar, choose Edit > Preferences (Ctrl K). When the Preferences dialog box appears, select *E-mail* in the left-hand list and the *E-mail* panel will appear on the right (**Figure 7.10**).

2. Your default email program will be listed in the *Send E-mail Using* text window. If you want to use another program, click the drop-down menu and make a choice from those listed (any email programs stored on your computer are automatically listed). If you want to change where Photoshop Album stores email attachments, click the drop-down menu to choose *Other (save to disk)*, then click *Browse* and navigate to your preferred folder (**Figure 7.11**).

3. In the Settings section, use the *Presets For* drop-down menu to choose the default size you want to use when sending photos. Your choice will automatically change the settings in the *Size and Quality* section, but you can adjust these defaults using the *Maximum Photo Size* drop-down menu and the *Quality* slider (left for poorer quality, right for higher). When you are satisfied with the settings, click *OK* to close the Preferences dialog box.

✔ Tips

■ These settings will be used automatically when you email a photo. But you can reopen the Preferences dialog box to change them whenever you have a particular set of photos you want emailed at a different size and quality.

■ If you use AOL for sending email, log on to AOL and make sure that the email preference under Associations is set to AOL. That will ensure that Photoshop Album automatically uses AOL to email photos.

To open the contact book:

◆ From the Menu bar, choose View > Contact Book (**Figure 7.12**). The contact book will appear, floating on top of the Photo Well.

To add contacts to the contact book:

1. Open the contact book and click *New Contact* (**Figure 7.13**). When the New Contact dialog box appears, fill in the fields you need (you don't have to fill in the *Address* tab), and click *OK* (**Figure 7.14**). The Contact Book dialog box will reappear with the new contact added.

2. You can repeat step 1 to create more contacts, or click *OK* to close the contact book.

Figure 7.12
To open the contact book, choose View > Contact Book.

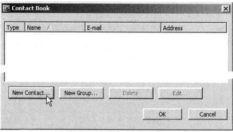

Figure 7.13 To add contacts to the Contact Book, click *New Contact*.

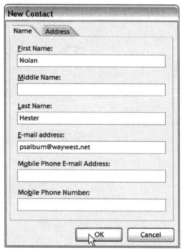

Figure 7.14 Use the New Contact dialog box to add email addresses.

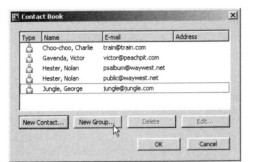

Figure 7.15 To add groups to the contact book, click *New Group*.

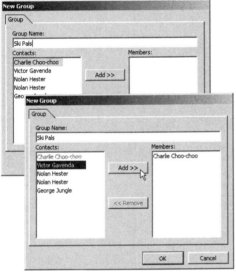

Figure 7.16 Type a name in the *Group Name* text window (top), then click *Add* to build the right-hand *Members* list (bottom).

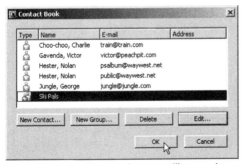

Figure 7.17 New contacts and groups will appear in the contact book.

To add groups to the contact book:

1. Open the contact book and click *New Group* (**Figure 7.15**).

2. When the New Group dialog box appears, type a name into the *Group Name* text window (top, **Figure 7.16**).

3. Select names in the left-hand *Contacts* list, then click *Add* to build the right-hand *Members* list (bottom, **Figure 7.16**).

4. Once you finish adding names to the group, click *OK* to close the dialog box. The contact book will reappear with the new group added (**Figure 7.17**).

To change or delete contacts and groups:

1. Open the contact book, select the contact or group you want to change, and click *Edit* or *Delete*.

2. If you choose *Edit*, when the Edit Contact or Edit Group dialog box appears, make your changes, and click *OK*. The contact book will reappear with the entry updated.

 If you choose *Delete*, when the Confirm Deletion alert dialog box appears, click *OK*. The contact book will reappear with the entry deleted.

To email photos:

1. Select one or more photos in the Photo Well ([Shift]-click to select adjacent photos; [Ctrl]-click to select non-adjacent photos).

2. In the Shortcuts bar, click the Share icon, and choose E-mail from the drop-down menu (top, **Figure 7.18**). Or from the Menu bar, choose File > Attach to E-mail ([Ctrl][Shift][E]) (bottom, **Figure 7.18**).

3. When the Attach Selected Items to E-mail dialog box appears, the photo(s) will be displayed in the left-side *Attachments* panel (**Figure 7.19**). Names and groups from your contact book will be listed in the middle *Select Recipients* panel, from which you can select the ones you want to send email to. Or you can click *Add Recipient*, then use the dialog box that appears to manually add a name not already in the contact book (**Figure 7.20**). Click *OK* to close the dialog box and that name will be added to the *Select Recipients* panel.

Figure 7.18 To email selected photos, click the Share icon and choose E-mail from the drop-down menu (top), or choose File > Attach to E-mail (bottom), or press [Ctrl][Shift][E].

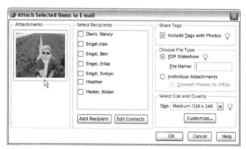

Figure 7.19 The photo to be emailed appears in the left-side *Attachments* panel.

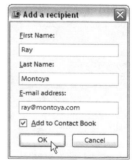

Figure 7.20 Use the *Add a recipient* dialog box to add a name not already in your contact book.

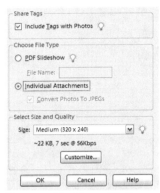

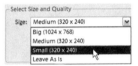

Figure 7.21 The *Choose File Type* panel lets you send the photos as a *PDF Slideshow* or as *Individual Attachments*, which you can then adjust in the *Select Size and Quality* panel.

Figure 7.22
Use the *Size* drop-down menu to quickly change the default email settings.

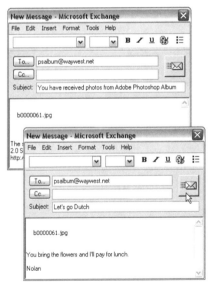

Figure 7.23 Change the default subject line (top) to one of your own, then type in your message, and click *Send* (bottom).

4. The *Choose File Type* panel gives you the choice of sending your photos as a *PDF Slideshow* or as *Individual Attachments* (**Figure 7.21**). (See first *Tip* on page 142 on deciding which to use.) If you select *PDF Slideshow*, identify it in the *File Name* text window. It doesn't need to be the PDF's actual file name, just something to help you identify the batch being emailed. While the *Size* drop-down menu lists the choice you made when setting your email preferences on page 137, you can change it now if you like (**Figure 7.22**). Once you've made your choices, click *OK* to close the dialog box.

5. If you chose *Individual Attachments* in step 5, skip to step 7. If you chose *PDF Slideshow* in step 5, a status bar dialog box will appear briefly as the photos are converted to PDF, then an alert dialog box will appear with an estimate of how long it will take with a dial-up connection to upload (and the recipient to download) the PDF. If you find the time estimate too long to be worth it, click *Cancel*. Otherwise, click *Continue* to close the dialog box.

6. When the email message dialog box appears, it will be addressed to the recipients chosen in step 4 and the photos will be attached (top, **Figure 7.23**). Change the default subject line to one of your own, type in your message, and click *Send* (bottom, **Figure 7.23**).

7. Your email program will launch automatically, make the connection, and send the message and photos. Once the message is sent, you can continue working in Photoshop Album or quit the program.

(continued on next page)

EMAILING PHOTOS

✔ Tips

- The advantage of sending a PDF (Adobe's Portable Document Format), is that it lets you control the order in which the recipient sees your photos. The drawback is that viewing the PDF slideshow requires a special plug-in for Adobe Acrobat Reader. If your recipient doesn't have the plug-in (and I didn't despite being a long-time Acrobat user), they will be guided step-by-step on how to download it from Adobe's Web site. It's pretty easy and only takes a minute, but if your recipient isn't comfortable installing a plug-in, then sending the photos as individual attachments will be less hassle.

- In step 4, if you are emailing photos to someone who has Photoshop Album 2 installed on their computer, you can check *Include Tags with Photos* in the *Share Tags* panel (**Figure 7.21**). The recipient's copy of Photoshop Album 2 will automatically add each photo's tag information to its own catalog. This is a great way to share photos, for example, with other family members while sparing them the trouble of creating tags of their own for the photos.

- In step 5, besides using the *Size* drop-down menu, you can change the default settings of the selected size for that particular photo by clicking *Customize* (top, **Figure 7.24**). When the preferences dialog box appears (bottom, **Figure 7.24**), drag the *Quality* slider to a new setting and click *OK* to return to the main email dialog box.

Figure 7.24 Change the default settings for the selected size by clicking *Customize* (top) and then adjusting the *Quality* slider (bottom).

Figure 7.25 To email projects, right-click the project in the Photo Well and from the shortcuts menu, choose *Publish*.

Figure 7.26 In the Creations Wizard dialog box, click *E-mail* in the right-hand *Output Options* panel.

Figure 7.27 Prior to being emailed, the project appears in the left-side *Attachments* panel.

To email projects:

1. Right-click the project in the Photo Well and from the shortcuts menu, choose *Publish* (**Figure 7.25**).

2. When the Publish view of the Creations Wizard dialog box appears, click *E-mail* in the *Output Options* panel (**Figure 7.26**).

3. When the Attach Creation Items to E-mail dialog box appears, the project will be displayed in the left-side *Attachments* panel (**Figure 7.27**). To continue, see step 3 of *To email photos* on page 140.

EMAILING PROJECTS

Sharing Photos with Phones and PDAs

Photoshop Album 2 lets you share photos with mobile phones and PDAs (handheld personal digital assistants). Naturally, there are some restrictions: Compatible mobile phones must be able to receive email messages and download images as attachments. Some mobile phones can only receive images if the sender uses the same mobile phone service. Check the carrier's Web site for details.

To share photos from Photoshop Album 2, your PDA must be running version 3.5, 4.0, or 4.1 of the Palm operating system. You'll also need to install on your computer the Adobe Reader for Palm OS, which helps you format the photos for PDA displays. For more information, go to:

http://www.adobe.com/support/

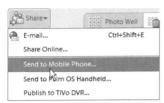

Figure 7.28 To share photos with a mobile camera phone, make your selection(s) in the Photo Well, click the Share icon, and choose Send to Mobile Phone.

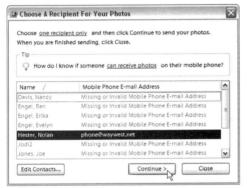

Figure 7.29 Select one name/address from the list of possible recipients and click *Continue*. Click *Edit Contacts* if you need to add a name or address to the list.

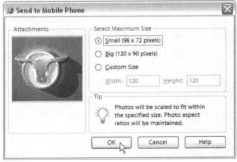

Figure 7.30 Use the Send to Mobile Phone dialog box to choose a size for the photo you want to send.

To share photos with a mobile camera phone:

1. Select one or more photos in the Photo Well (Shift-click to select adjacent photos; Ctrl-click to select non-adjacent photos).

2. In the Shortcuts bar, click the Share icon, and choose Send to Mobile Phone from the drop-down menu (**Figure 7.28**).

3. The Choose A Recipient For Your Photos dialog box will appear and highlight any entries in your contact book that contain mobile phone email addresses. Click *Edit Contacts* if you need to add or change an entry. Select just one name/address from the list and click *Continue* (**Figure 7.29**).

4. When the Send to Mobile Phone dialog box appears, choose what size photo you want to send (**Figure 7.30**). Given the size of mobile phone screens, it's best to use the default *Small (96 x 72 pixels)*. Click *OK* to close the dialog box.

5. At this point, your email program will display a message for the recipient and the steps are the same as sending any photo by email. For details, see steps 6–7 in *To email photos* on page 141.

6. After you send the photo, the Choose A Recipient For Your Photos dialog box will remain open, enabling you to send the same photo to another mobile camera phone. Click *Close* after you are done emailing the photo to all recipients.

To share photos with a handheld PDA:

1. Connect your PDA to your computer and launch the Adobe Reader for Palm OS program. Back in Photoshop Album, select one or more photos in the Photo Well (**Shift**-click to select adjacent photos; **Ctrl**-click to select non-adjacent photos).

2. In the Shortcuts bar, click the Share icon, and choose Send to Palm OS Handheld from the drop-down menu (**Figure 7.31**). If you haven't already installed Adobe Reader for Palm OS on your computer, you'll be prompted to download it (**Figure 7.32**). You'll need to restart after you install it.

3. Assuming you have already installed Adobe Reader for Palm OS, Photoshop Album will automatically generate a PDF file of the photo and send it to the Adobe Reader for Palm OS. Press the synch button on your PDA and the photo(s) will be transferred.

✔ Tips

- Until all the kinks are worked out, successfully moving photos from Photoshop Album into your PDA remains a bit of an art. You'll find lots of helpful advice at the Adobe Reader for Palm OS online forum. To reach the forum, go to: http://www.adobe.com/support/forums/ and log in.

- If you have a TiVo Series 2 DVR and subscribe to TiVo's Home Media Option, you can use Photoshop Album to show photos on your television. For more information, see: http://www.adobe.com/products/photoshopalbum/partners.html

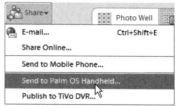

Figure 7.31 To share photos with a handheld PDA, make your selection(s) in the Photo Well, click the Share icon, and choose Send to Palm OS Handheld.

Figure 7.32 If you haven't installed Adobe Reader for Palm OS on your computer, you'll be prompted to download it.

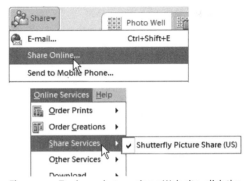

Figure 7.33 To share photos using a Web site, click the Share icon in the Shortcuts bar and choose Share Online from the drop-down menu, or from the Menu bar, choose Online Services > Share Services and select an online photo service from the submenu.

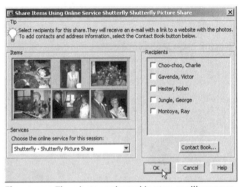

Figure 7.34 The photos selected in step 2 will appear in a dialog box, along with a list of your contact book addresses.

Sharing Photos Using a Web Site

Why wait to download photos and then wait some more as they print out, when you can just surf over for a peek at the grandchildren's Web photo album? While you could build your own Web site for those photos, most online photo services offer pre-built sites. All you need to do is post the photos and, if you like, assign a password, so that only friends and relatives can reach the site. Send them an email with the Web address and password, and you can get back to taking more photos.

To share photos using a Web site:

1. Make sure you've set up an account with an online photo service that offers Web sharing. (See *To set up online photo services* on page 134.) Open your computer's connection to the Internet.

2. In the Photo Well, select the photos or project you want to share on the Web site.

3. In the Shortcuts bar, click the Share icon and choose Share Online from the drop-down menu, or from the Menu bar, choose Online Services > Share Services and select an online photo service from the submenu (**Figure 7.33**).

4. The photos selected in step 2 will appear in a dialog box with a list of your contact book addresses (**Figure 7.34**). Use the *Recipients* panel to select who should receive an email notice about the Web site. Check that the drop-down menu at the bottom of the dialog box lists the online photo service you want to use, and click *OK*.

(continued on next page)

SHARING PHOTOS USING A WEB SITE

5. If this is the first time you've used this service, two dialog boxes will appear. The first explains the terms of using the online services. Click *Agree* to continue. The second dialog box says Adobe is not responsible for any problems with the online photo service providers. Click *OK* to continue.

6. When the Create or Modify Online Service Accounts dialog box appears, the online photo service chosen in step 3 already will be selected, so click *Select* (top, **Figure 7.35**). A progress bar will appear briefly as you connect to the online photo service (bottom, **Figure 7.35**).

7. When the Online Services Wizard appears with the selected online photo service's welcome screen, log in (**Figure 7.36**). Another progress bar will appear briefly as your user name and password are authenticated.

Figure 7.35 The photo service chosen in step 3 already will be selected, so click *Select* (top) and a progress bar will appear briefly as you connect to the service (bottom).

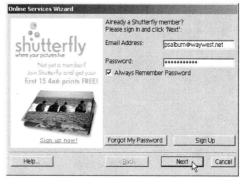

Figure 7.36 Log in when the welcome screen of the online photo service appears.

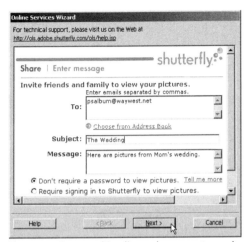

Figure 7.37 Enter a subject line and message to send to everyone being told about the Web site photos.

Figure 7.38 Uploading photos to the online service can take a few minutes to several hours, depending on your Internet connection and the number of photos.

Figure 7.39 Once they receive your message, recipients can log on and see the photos online.

8. A dialog box will appear listing the recipients chosen in step 4, and ask you to enter a subject heading for the email, along with a brief message (**Figure 7.37**). After doing so, the online photo service will upload your photos and track the status with a progress bar (**Figure 7.38**). That can take a few minutes to several hours, depending on your Internet connection and the number of photos. Once the upload finishes, you can log out from the online photo service. An email will be sent to each recipient with your message and the address of the Web site address where the photos can be seen (**Figure 7.39**).

Sharing Photos on a CD or DVD

Burning your photos or projects to a CD or DVD is a great way to share them with others because it lets you sidestep lots of hardware compatibility issues. It won't matter if your parents' computer is a Macintosh. In fact, if you create a video CD, as explained on page 119, the disc can even be viewed on a DVD player hooked to a television. There's one more advantage: If you burn a Photoshop Album project as a PDF (Adobe's Portable Document Format), you can preserve all your project's sequencing and titles.

A less fancy, but just as valuable, way to burn a CD is to store individual photos for safe keeping in another location. If you like, you also can use this option to free up space on your hard drive by moving the original images "offline" to the disc. Photoshop Album will keep smaller thumbnails of the images on your computer and, if you need to work on the originals, it will ask for the burned disc by name.

Figure 7.40 To burn a project to a CD or DVD, click *Burn* in the right-hand *Output Options* panel.

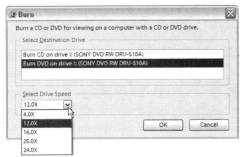

Figure 7.41 In the Burn dialog box, choose a CD or DVD burner, select a drive speed in the drop-down menu if necessary, and click *OK* to start the burn.

Figure 7.42 Burning the disc involves a multi-step process that can take as long as 20 minutes.

Figure 7.43
A dialog box will alert you when the burn is finished.

To burn a project to a CD or DVD:

1. Select your project in the Photo Well, right-click it, and choose *Publish* from the shortcuts menu.

2. When the publish view of the Creations Wizard appears, click *Burn* in the right-hand *Output Options* panel (**Figure 7.40**).

3. When the Burn dialog box appears, choose the CD or DVD burner you want to use and use the *Select Drive Speed* drop-down menu if you want to burn at a rate slower than the listed default, and click *OK* (**Figure 7.41**). (See first *Tip* below.) Insert a blank disc when asked to do so, and the project will be written to the disc, a multi-step process that can take as long as 20 minutes, depending on the size of the project and your burner's speed (**Figure 7.42**).

4. Once the burn is completed, a dialog box will alert you that the disc is ready (**Figure 7.43**). Click *OK* to close the dialog box and then eject it for labeling.

✔ Tips

■ In step 3, Photoshop Album automatically chooses the fastest speed at which your burner can handle the disc. While you cannot set it faster than the default, you may want to set it for a slower speed if you have had problems getting consistent burns at the default speed.

■ In step 3, if you have a burner that can format CDs and DVDs, it will be listed twice in the Burn dialog box—once for each format—so pay attention to which one you select (**Figure 7.41**).

BURNING A PROJECT TO A CD OR DVD

To burn individual photos to CD or DVD:

1. Select the photos in the Photo Well you want to archive, and from the Menu bar, choose File > Burn (Ctrl B) (**Figure 7.44**).

2. When the *Choose an Action* view of the Burn/Backup dialog box appears, it will select *Copy/Move Files* automatically, so click *Next* (**Figure 7.45**). (For more information on the *Backup the Catalog* option, see page 62.)

3. When the *Copy/Move Options* view of the Burn/Backup dialog box appears, Photoshop Album assumes you only want to copy the images to a disc, still leaving them on your computer (**Figure 7.46**). If you want to move the images off the computer entirely, freeing up space on your hard drive by leaving only thumbnail images on the computer, select *Move Files*. By default, Photoshop Album copies or moves only your edited files (*or* originals if they've never been edited) to the disc. If you want to move the edited *and* original versions, select *Copy/Move Edited and Original Files*. Once you have made your choices, click *Next*.

Figure 7.44 To burn selected individual photos to CD or DVD, choose File > Burn (Ctrl B).

Figure 7.45 The *Choose an Action* view of the Burn/Backup dialog box automatically selects the *Copy/Move Files* option, so click *Next*.

Figure 7.46 Photoshop Album assumes you only want to copy the images to a disc, still leaving them on your computer. If you want to free up space on your hard drive, select *Move Files* to move the images off the computer entirely.

Figure 7.47 Photoshop Album will ask for a blank disc to calculate the best burn speed (top). When the *Destination Settings* view of the Burn/Backup dialog box then appears, you may give the burn session a new *Name* or select a lower *Write Speed* (bottom).

Figure 7.48 Click *Burn* (top) to start a multi-step process, which will be tracked by a series of progress bars.

4. Photoshop Album will ask you to insert a blank disc to calculate the best burn speed (top, **Figure 7.47**). When the *Destination Settings* view of the Burn/Backup dialog box appears (bottom, **Figure 7.47**), you may give the burn session a new *Name* or select a lower *Write Speed* (see the first *Tip* on the previous page about write speeds). Once you've chosen your settings, click Done to close the dialog box.

5. In the next dialog box to appear, click *Burn* to start a multi-step process, which will be tracked by a series of progress bars (**Figure 7.48**).

6. Once the disc(s) have been burned, you'll be asked if you want to verify that the disc was burned properly (**Figure 7.49**). Click *Verify* and follow the dialog box prompts to test the disc(s). Once the testing is complete, click *OK* to close the dialog box.

Figure 7.49 Once the disc(s) have been burned, click *Verify* to make sure they can be read.

Exporting Photos

Occasionally, you may need to export photos out of Photoshop Album. Exports are most likely in two situations: when another program requires a particular file type or when you need to move a whole group of photos to another location, perhaps to then import them into a Web blog. You cannot export Photoshop Album projects but anything else can be easily reformatted. To decide which file format to export in, check the requirements of the other program you'll be using. For a quick look at the differences between JPEG and TIFF files, see *A Tale of Two Formats* on page 8.

To export photos:

1. In the Photo Well, select the photos you want to export, and from the Menu bar, choose File > Export.

2. When the Export Selected Items dialog box appears, choose a *File Type* based on the needs of the program you'll be using to import the images (**Figure 7.50**). Use the *Photo Size* drop-down menu to choose what size the exported photo should be (**Figure 7.51**). If you choose *JPEG* as your format, use the *Quality* slider to set the level of detail retained (higher is better).

3. In the *Location* panel, click *Browse* and navigate to where you want the exported photos stored. Use the *Filenames* panel to either keep the original name or create a *Common Base Name*, from which sequentially numbered file names will be generated.

4. Once you have chosen your settings, click *Export*. A progress bar will appear briefly, then a dialog box confirming the export will appear. Click *OK* and you will be returned to the Photo Well.

Figure 7.50 Choose a *File Type* based on the requirements of the program to which you are exporting.

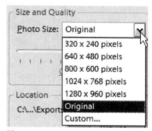

Figure 7.51 Use the Export dialog box's *Photo Size* drop-down menu to choose the size for the exported photo(s).

EXPORTING PHOTOS

Figure 7.52 Make sure the paper *Size* is correct or change it with the drop-down menu.

Printing Photos

When it comes to printing your photos, Photoshop Album offers two different approaches: use your own desktop printer (what Photoshop Album calls local printing) or order prints from an online photo service. Using your own printer means no waiting and Photoshop Album includes some great printing options. The Picture Package, for example, arranges a preset variety of photo sizes on a single page. The results resemble the photo packages school photographers often sell. The advantage of using an online photo service is getting photo lab-quality prints—and not having to bother with matching the right inks and paper to your printer.

To set your printer options:

1. From the Menu bar, choose File > Page Setup ([Ctrl][Shift][P]).

2. When the Page Setup dialog box appears, make sure the paper *Size* is set for the photo-quality paper you'll be using or change it with the drop-down menu (**Figure 7.52**). In most cases, the *Source* will not need to be changed, though you may need to change the *Orientation*.

3. If you have more than one printer (increasingly likely as people buy different printers to handle documents and photos), click *Printer* to make sure you have your photo printer activated. When you return to the Page Setup dialog box, click *OK* to close the dialog box.

PRINTING PHOTOS

To print photos on your own printer:

1. In the Photo Well, select the photos or project you want printed. In the Shortcuts bar, click the printer icon and choose Print, or from the Menu bar, choose File > Print ([Ctrl][P]) (**Figure 7.53**).

2. If you have selected pictures with too low a resolution to look good in print, a warning dialog box will list their names. If you want the print anyway, click *OK* and proceed. Otherwise, when the Print Selected Photos dialog box appears in step 3, click *Cancel* to return to the Photo Well where you can deselect those photos.

3. When the Print Selected Photos dialog box appears, the selected photos will appear in the left-hand panel (**Figure 7.54**). In the top-middle *Layout* panel, choose whether you want to print:

 ▲ **Individual Prints** (**Figure 7.55**). If you make this choice, select your *Print Sizes* (you can only choose one), decide if you want to just *Print Single Photo Per Page* (which takes a lot more pages), and whether to *Crop to Match Print Proportions* (try it both ways, using the *Preview* panel to see if the crop cuts out key parts of the photos). Use the arrows in the *Use each photo* text window to set how many prints of each photo you want.

Figure 7.53 To print photos on your own printer, click the printer icon in the Shortcuts bar and choose Print, or from the Menu bar, choose File > Print ([Ctrl][P]).

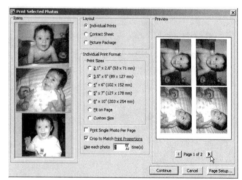

Figure 7.54 Photos to be printed appear in the left-hand panel, options in the center, and a *Preview* panel on the right.

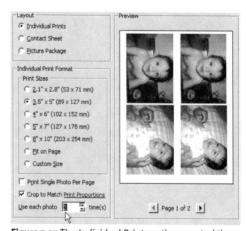

Figure 7.55 The *Individual Prints* options control the size, cropping, and number of copies.

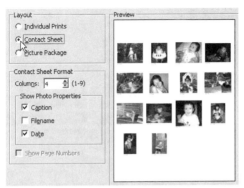

Figure 7.56 The *Contact Sheet* options control the layout and information shown for each photo.

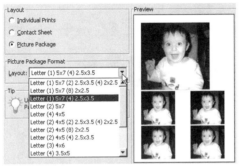

Figure 7.57 The *Picture Package* layout offers different mixes of photo sizes on the same sheet.

Figure 7.58
The *Preview* panel shows how the photos will be laid out on each page.

▲ **Contact Sheet** (**Figure 7.56**). If you make this choice, use the arrows in the *Columns* text window to control the arrangement of the photos, then select any of the three items in the *Show Photo Properties* panel that you want to appear. If your selections will take more than a single page, you will be able to select *Show Page Numbers* as well.

▲ **Picture Package** (**Figure 7.57**). If you make this choice, use the *Layout* drop-down menu to choose your mix of photo sizes.

4. The right-hand *Preview* panel will show how the photos will be laid out on the pages. If the photos will require more than one page, you can click the forward and back arrows to see previews of all the pages (**Figure 7.58**).

5. Once you have made your choices, click *Continue* in the lower right of the Print Selected Photos dialog box. The print dialog box for your printer will appear, where you can make further adjustments if needed, and then click *Print*. The dialog box will close, your photos will begin printing, and the Photo Well will reappear.

To order prints online:

1. Open your computer's connection to the Internet.

2. In the Photo Well, select the photos or project you want printed, then click the printer icon in the Shortcuts bar and choose Order Prints, or from the Menu bar, choose Online Services > Order Prints and select an online photo service from the submenu (**Figure 7.59**).

3. If this is the first time you've used this service, two dialog boxes will appear. The first explains the terms of using the online services. Click *Agree* to continue. The second dialog box says Adobe is not responsible for any problems with the online photo service providers. Click *OK* to continue. A dialog box will display all the photos you've selected, with a drop-down menu at the bottom listing the online photo service you picked in step 2. Click *OK* to continue (**Figure 7.60**).

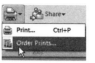
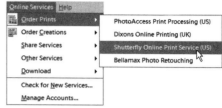

Figure 7.59 To order prints online, click the printer icon in the Shortcuts bar and choose Order Prints (top), or from the Menu bar, choose Online Services > Order Prints and select a service from the submenu.

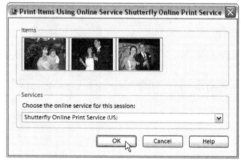

Figure 7.60 All the prints you selected for printing will appear in a dialog box with a drop-down menu listing your online photo service. Click *OK* to continue.

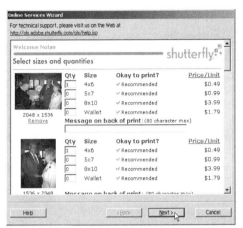

Figure 7.61 Onscreen instructions guide you through such choices as how many prints to order.

4. When the Online Services Wizard appears with the welcome screen for the selected online photo service, log in using your account name and password.

5. Follow the onscreen step-by-step instructions, which guide you through such choices as how many prints to order (**Figure 7.61**).

6. After filling in the shipping address, other information, and calculating the cost, you'll be asked to upload your photos, which can take a few minutes to several hours, depending on your Internet connection, and the number and size of the photos. Once the upload finishes, you can log out from the online photo service.

✔ Tip

■ In step 5, you have the option of ordering prints and having them shipped to another address, which is a great option for sending relatives prints without a bill.

To order a bound photo book online:

1. Open your computer's connection to the Internet.

2. In the Photo Well, select the photo book project you want printed, then from the Menu bar, choose Online Services > Order Creations and select an online photo service from the submenu (**Figure 7.62**).

3. The photo book will appear in a dialog box (**Figure 7.63**). The drop-down menu at the bottom of the dialog box already will list the online photo service you picked in step 2, so click *OK*.

4. If this is the first time you've used this service, two dialog boxes will appear. The first explains the terms of using the online services. Click *Agree* to continue. The second dialog box says Adobe is not responsible for any problems with the online photo service providers. Click *OK* to continue.

5. When the Online Services Wizard appears with the welcome screen for the selected online photo service, log in using your account name and password (**Figure 7.64**).

6. Follow the onscreen step-by-step instructions, which are actually simpler than those for ordering prints since you already made most of the format and style choices when creating the book project.

7. After filling in the information fields, you'll be asked to upload (or build) the PDF file of the book, which you created on pages 126–127 (**Figure 7.65**). Once the upload finishes, you can log out from the online photo service.

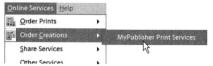

Figure 7.62 To order a bound photo book, choose Online Services > Order Creations and make a choice from the submenu.

Figure 7.63 The photo book will appear in a dialog box with the online photo service already selected.

Figure 7.64 Log in when the welcome screen for the photo book printing service appears.

Figure 7.65
A PDF version of the photo book will be created and uploaded during the order process.

INDEX

+/– icons, 90

A

Acrobat Reader, 142
ActiveShare, 10, 14
Actual Pixels icon, 90
Add Caption command, 31
Add Photos to Creation dialog box, 110
Adjust Date and Time dialog box, 36–37
Adjust Temperature slider, 101
Adobe
 Acrobat Reader, 142
 ActiveShare, 10, 14
 PhotoDeluxe, 10, 14
 Photoshop, 102, 105, 106
 Photoshop Album (See Photoshop Album)
 Photoshop Elements, 102
 Web site, xxvi, 144, 146
Adobe Acrobat Reader, 142
Adobe Gamma dialog box, 95–96
Adobe Reader for Palm OS, 144, 146
Album. See Photoshop Album
Album template, 108
albums. See photo albums
AOL, 137
Apply Filters panel, 94
archiving. See backups
Arrangement drop-down menu, 25
Aspect Ratio drop-down menu, 92
Attach Creation Items to E-mail dialog box, 143

Attach Selected Items to E-mail dialog box, 140
Attach to E-mail command, 140
Audio Caption icon, 33
audio captions, 33–34
Auto Fix command, 99
Auto Fix Photos dialog box, 99
Auto Fix Selected Photos command, 99

B

Back button, 111
background music, 117, 122
Backup command, 62
backups, 62–69
 creating, 62–66
 full vs. incremental, 66
 importance of, 61
 recovering/restoring catalogs from, 67–69
 verifying, 65, 153
batteries, digital camera, 3, 6
Before & After tab, 90
binoculars icon, 75
Black & White filter, 94
Body Pages panel, 116
bound photo books, 126–127, 160
Brief button, 29
brightness, xxii, 95–96, 97
Burn/Backup dialog box, 62–64, 152–153
Burn dialog box, 151
burn speed, 151, 153
burning, CD/DVD, 62–66, 150–153
By Caption or Note command, 83

By Color Similarity with Selected Photo(s) command, 85
By History command, 84
By Media Type command, 85

C

Calendar View, xix, 78, 80–82
calendars, photo, 124–125
calibration, monitor, 95–96
camera phones, 18–20, 144–145
cameras. See also digital cameras
 importing photos from, 3–6
 and red-eye reduction, 93
 setting import preferences for, 2–3
 using metadata captured by, 29, 30
Cancel button, 91
captions
 adding/removing, 31–34
 applying to groups of photos, 32
 finding photos by, 83
 fonts used for, 113
 maximum length of, 32
 new features, 32
 purpose of, 23
 in specific types of projects
 bound photo books, 126, 127
 photo albums, 114
 photo calendars, 124–125
 slideshows, 116
 vs. other organization tools, 23
card readers, 2–3, 7
cards, greeting, 120–123
Catalog dialog box, 67, 70

catalogs, 61–71
 backing up, 61, 62–66
 copying, 71
 creating, 70
 naming/renaming, 66, 70
 purpose of, 61
 recovering/restoring, 67–69
 switching between, 71
categories, tag, 46–48, 51–52, 53
CD
 backing up to, 64–65
 burning photos/projects to,
 150–153
 importing photos from, 15–17
 installing program from, xiii–xiv
 putting slideshows on, 119
 restoring catalogs from, 68–69
CD icon, 15
Check for New Services
 command, 135
Clear button, 75
Clear Caption command, 32
Collapse All Tags command, 53
collections, 55–60
 adding photos to multiple, 57
 creating, 56–57
 deleting, 58
 naming/renaming, 56, 60
 purpose of, xii, 23
 rearranging photos in, 59
 removing photos from, 58
 vs. other organization tools,
 23, 55
Collections pane, 55–60
color
 converting to black-and-
 white, 94
 finding photos by, 85
 fixing, 97–98, 101
color balance, 96
color saturation, 97
Color Similarity option, 26, 85
color temperature, 97, 101
companion Web site, xxvi
computer
 calibrating monitor for, 95–96
 hardware/software
 requirements, xii
 importing photos from, 10–14
 searching for photos on, 12–13
Confirm Deletion from Catalog
 dialog box, 21
Confirm Tag Deletion dialog
 box, 54

Connect to Camera command, 4
contact book
 adding/deleting contacts in,
 138–139
 emailing photos to names
 in, 140
 opening, 138
 purpose of, 136
Contact Sheet options, 157
contrast, xxii, 95–96, 97
copyrighted photos, 13
Correct Color slider, 101
Create Collection dialog box, 56
Create mode, xxiii
Create New Category dialog
 box, 46
Create New Sub-Category dialog
 box, 47
Create tab, xxi
creations, 55, 107. See also
 projects
Creations Wizard, 108–127
 basic steps for using, 108
 creating specific types of
 projects with
 bound photo books,
 126–127
 eCards, 120, 122–123
 greeting cards, 120–121
 photo albums, 114–115
 photo calendars, 124–125
 slideshows, 116–119
 video CDs, 119
 downloading new templates
 for, 113
cropping photos, 8, 92
CRT monitors, 95

D

Daily Note feature, 82, 83
Darken Highlights slider, 100
databases, photo, 61
date
 changing photo's, 36–37
 finding photos by, 78–82
 hiding/showing, 26
 and photo source, 37
deleting
 collections, 58
 contacts/groups, 139
 photos, 3, 21, 58
 tags, 54
desktop, using photos on, 133

Details option, 26
device drivers, digital camera, 3
digital cameras. See also cameras
 battery considerations, 3, 6
 connecting to computers, 3, 4
 and date/time information, 37
 device drivers for, 3
 and pixel counts, 131–132
 popularity of, 107
 setting image resolution on, 132
Digital Photography Review, 132
digital photos. See also photos
 comparing different sets of, xix
 date and time for, 37
 naming/renaming, 35, 105, 106
 pros and cons of, xi
 size considerations, 131–132
Display Properties dialog box, 95
DVD
 backing up to, 64–65
 burning photos/projects to,
 150–153
 importing photos from, 15–17
 installing program from,
 xiii–xiv
 restoring catalogs from, 68–69

E

eCards, 120, 122–123
Edit Collection dialog box, 60
Edit Contact dialog box, 139
Edit Group dialog box, 139
edit icon, 48
Edit Selected Tag command, 51
Edit Tag dialog box, 49, 51
Edit Tag Icon dialog box, 50
editing photos, 87–106
 automatically, 97–99
 calibrating monitor prior to,
 95–96
 comparing before/after views
 while, 90
 with external editing
 programs, 102–106
 with Fix Photo dialog box,
 89–94, 97–98, 100–101
 manually, 100–101
 safeguarding of originals prior
 to, 87
 undoing/redoing fixes
 while, 91
Elements, Photoshop, 102,
 105, 106

email, contacting author via, xxv
emailing photos, 136–143
 including tags when, 142
 selecting file type for, 141
 setting preferences for, 137
 setting up contact book for, 138–139
 using AOL, 137
Events category, 46
Expand All Tags command, 53, 76
Export dialog box, 154
Export Selected Items dialog box, 154
external editing programs, 102–106

F

Family category, 46
Favorites tag, 76
filenames
 changing, 35
 finding photos by, 83
 hiding/showing, 26
film roll icon, 25
Filters icon, 94
Find bar, 74, 75, 77, 83
Find by Caption or Note dialog box, 83
Find by Filename dialog box, 83
Find menu, 83
Find Photos mode, xxii
Find Photos tab, xxi
finding photos
 with Calendar View, 80–82
 by caption/note, 83
 by color, 85
 by date, 78–82
 by filename, 83
 by history, 84
 by media type, 85
 with Quick Guide, 10, 12
 with Shortcuts bar, 10
 by tag, 74–77
 with timeline, 78–79
Fit to Window icon, 90
Fix Color option, 97, 101
Fix icon, 89, 99
Fix Lighting option, 97, 100
Fix Photo dialog box, 89–94
 automatically fixing photos in, 97–98
 comparing before/after photos in, 90

converting photos to black-and-white in, 94
cropping photos in, 92
manually adjusting photos in, 100–101
opening, 89
removing red eye in, 93
undoing/redoing fixes in, 91, 93
zooming in/out on photos in, 90
Fix Photo mode, xxii
Fix Photos tab, xxi
folder icon, 25
folders
 attaching tags to, 43
 creating, 3
 creating tags based on, 44
 searching for photos in, 12–13
fonts, xxv, 113
footers, 109, 114, 126
Friends category, 46
Full Backup option, 66
Full Screen Preview button, 111

G

General view, 29
Get Photos by Searching for Folders dialog box, 12, 13
Get Photos from Files and Folders dialog box, 11
Get Photos icon/tab, xxi, 4, 7, 9
Get Photos mode, xxi
Getting Photos dialog box, 5, 11
greeting cards, 120–123

H

handheld PDAs. See PDAs
hard drive
 backing up to, 64, 66
 deleting photos from, 21
 freeing up space on, 150, 152
 restoring catalog from, 68
 searching for photos on, 12–13
 (See also finding photos)
 space required on, xii
hardware requirements, xii
headers, 109, 114, 126
Hidden tag, 75, 76
highlights, 100
history
 finding photos by, 84
 navigating view, xx

History view, 29
hourglass icon, 69

I

image formats, 8
import batches, attaching tags to, 43
importing photos, 1–20
 from ActiveShare, 10, 14
 from camera, 3–6
 from card reader, 3, 7
 from CD/DVD, 15–17
 from computer, 10–14
 how it works, 1
 information collected when, 73
 from mobile camera phone, 18–20
 from PhotoDeluxe, 10, 14
 from scanner, 8–9
 setting preferences for, 2–3
Incremental Backup option, 66
Individual Prints option, 156
installing program, xiii–xiv
InstallShield Wizard, xiii
instant slideshows, 24, 27. See also slideshows
Instant Tag button, 44
Internet Explorer, xii
italicized words, xxiv
Items Tagged with command, 74
Items with Unknown Date or Time command, 82

J

JPEG format, 8, 154

K

Keep Original Offline option, 16, 17
keyboard shortcuts, xxv

L

LCD monitors, 95
Lighten Shadows slider, 100
lighting, 94, 95, 97, 100
local printing, 155

M

magnifying glass icons, 90
Manage Accounts command, 134
media type, finding photos by, 85

INDEX

megapixels, 132
memory cards, 3, 18. *See also* card
 readers
memory requirements, xii
Menu bar, xviii, 9, 10, 14
menu commands, xxv
metadata, 29, 30
microphones, 33
Microsoft, xii, 3
Missing Files Check Before
 Backup dialog box, 62
Missing Files dialog box, 66
mobile camera phones, 18–20,
 144–145
modes, xxi–xxiii
monitors
 calibrating, 95–96
 recommended resolution
 for, xii
Move command, 66
Move Selected Items dialog
 box, 66
music, background, 117, 122

N

naming/renaming
 catalogs, 66, 70
 categories, 46, 47
 collections, 56, 60
 photos, 1–6, 35, 105
 projects, 113
New Catalog dialog box, 70
New Category command, 46
New Contact dialog box, 138
New Group dialog box, 139
New Sub-Category command, 47
New Tag command, 40
Next button, 111
notes. *See also* Daily Note feature
 adding to photos, 32
 changing, 48
 finding photos by, 83
 maximum length of, 32
 purpose of, 23

O

online photo services
 checking for new services
 offered by, 135
 and photo printing, 158–160
 setting up account with,
 134–135
 and Web sharing, 147

Online Services Wizard,
 148–149, 159
Open Catalog dialog box, 71
Options bar, xviii
Order Creations command, 160
Order Prints command, 158
organization tools, photo, 23.
 See also specific tools
Organize mode, xxii
Organize tab, xxi
Organize View command, 55
orientation, printer, 155
Output Options panel,
 112, 143, 151

P

Page Setup dialog box, 155
Palm operating system, 144, 146
patches, program, xxvi
PDAs, 144, 146
PDF files, 150, 160
PDF Slideshow option, 141, 142
Pentium processor, xii
People category, 46
personal digital assistants.
 See PDAs
photo albums. *See also* bound
 photo books
 creating, 114–115
 importing photos from, 10, 14
 viewing on Web, 147–149
photo books. *See* bound photo
 books
photo calendars, 124–125
photo-editing programs, 102–106
photo services. *See* online photo
 services
Photo Well, 24–28
 changing photo sizes in, 24
 changing photo's date/time in,
 36–37
 displaying filenames in, 26
 illustrated, xvii
 playing video clips in, 28
 rearranging view for, 25–26
 rotating photos in, 88
 sorting, xviii
 viewing instant slideshows
 in, 27
PhotoDeluxe, 10, 14
photos
 adding captions/notes to, 32
 backing up (*See* backups)
 burning to CD/DVD, 150–153

changing date/time for, 36–37
comparing different sets of, xix
converting color to black-and-
 white, 94
copyright considerations, 13
creating projects with (*See*
 projects)
cropping, 8, 92
default storage location for, 3
deleting, 3, 21, 58
editing (*See* editing photos)
emailing, 136–143
exporting, 154
finding (*See* finding photos)
importing (*See* importing
 photos)
manually adjusting, 100–101
naming/renaming, 1–6, 35, 105
printing, 155–160
removing red eye from, 93
resizing, 24
rotating, 88
safeguarding original, 87
searching for (*See* finding
 photos)
sharing (*See* sharing photos)
sorting, xviii
tagging (*See* tags)
tools for organizing, 23 (*See
 also* specific tools)
undoing/redoing fixes to, 91
viewing information about, 29
viewing on Web, 147–149
zooming in/out on, 24, 50, 89,
 90, 93
Photos Per Page drop-down
 menu, 114, 115, 116
Photoshop, 102, 105, 106
Photoshop Album
 and external editing programs,
 102, 105–106
 hardware/software
 requirements, xii
 installing, xiii–xiv
 launching automatically, 3
 main window, xvii
 modes, xxi–xxiii
 new features, xii
 serial number, xiii
 starting, xv, 3
 updates/patches for, xxvi
 upgrading from earlier version
 of, xiv, xv
 views, xix–xx

Photoshop Elements, 102, 105, 106
Picture Package, 155, 157
pixel counts, 131
Places category, 46
Portable Document Format. *See* PDF files
Preferences dialog box
 Camera or Card Reader settings, 2–3
 Editing settings, 103
 Email settings, 137
 File Names settings, 26
 Mobile Phone settings, 19
 Proxy File Size settings, 17
 Quick Guide settings, xvi
 Reconnect Missing Files settings, 66
 Scanner settings, 8
Presentations Options panel, 116, 117, 119, 122
Preview panel, 12, 156, 157
Print command, 156
Print Selected Photos dialog box, 156
printer icon, 156
printing photos, 155–160
 as contact sheets, 157
 as individual prints, 156
 as Picture Package, 157
 setting printer options for, 155
 using online photo service for, 158–160
 on your own printer, 156–157
projects, 107–129
 basic steps for creating, 108
 burning to CD/DVD, 150–151
 creating specific types of
 bound photo books, 126–127
 eCards, 120, 122–123
 greeting cards, 120–121
 photo albums, 114–115
 photo calendars, 124–125
 slideshows, 116–119
 defined, 107
 emailing, 143
 finding saved, 128
 fonts used for, 113
 naming/renaming, 113
 opening saved, 129
 publishing, 108, 112
 restoring from backups, 67–68
 sorting, 128

Properties window, 29–34
Proxy File Size drop-down menu, 17
proxy images, 1, 15
Publish command, 143
publishing
 bound photo books, 127
 greeting cards, 121, 123
 photo albums, 115
 photo calendars, 125
 slideshows, 112, 118

Q

Quality settings, scanned image, 8
Quality slider, 137, 142, 154
Quick Guide
 finding photos on computer with, 10
 importing photos from camera with, 4
 importing photos from scanner with, 9
 tabs, xxi
 turning on/off, xvi

R

RAM, xii
Readme file, xiv
Reconnect Missing Files dialog box, 62, 63, 66
Recover Catalog dialog box, 67
red-eye reduction/removal, 93
Redo Fix Photo command, 91
Remove Tag command, 45
Rename command, 35
renaming. *See* naming/renaming
resolution
 monitor, xii
 photo, 131–132, 156
 printer, 156
Restore dialog box, 68
restoring catalogs, 67–69
Revert to Original option, 91, 105
Rotate commands/icons, 88
Rotating Photos dialog box, 88

S

saturation, 97
Save As dialog box, 106
scanners, 8, 9, 37
SCSI connection, 8
Search Hard Drive icon, 12

searching for photos. *See* finding photos
Select a Template view, 113
Select Audio File dialog box, 33
Send to Mobile Phone dialog box, 145
Sepia filter, 94
serial number, xiii
Set as Desktop Wallpaper command, 133
Set Date and Time dialog box, 37
Set Date Range dialog box, 79
shadows, 100
Share icon, 140
Share mode, xxiii
Share Online command, 147
Share tab, xxi
sharing photos, 131–160
 by burning to CD/DVD, 150–153
 by exporting, 154
 with mobile phones, 144–145
 with PDAs, 144, 146
 by printing, 155–160
 by putting on Web site, 147–149
 by sending via email, 136–143
 size considerations, 131–132
 by using on desktop, 133
Sharpen option, 97, 98
shortcuts, keyboard, xxv
Shortcuts bar
 finding photos with, 10
 illustrated, xviii
 importing photos with, 4, 7, 9
 navigating view history with, xx
Show All button/icon, 6, 56
Show/Hide Properties icon, 30
Show Properties command, 30
similar-color searches, 85
Slideshow command, 27
Slideshow icon, 27
slideshows
 adding background music to, 117
 computer-generated *vs.* regular, 116
 creating, 116–119
 fine-tuning, 117
 instant *vs.* full-fledged, 27
 PDF, 141, 142
 publishing, 112, 118

slideshows *(continued)*
 showing captions with photos
 in, 116
 using transitions in, 117, 118
 viewing in Photo Well, 27
software requirements, xii
sorting photos/projects, xviii, 128
Specify Audio File dialog box, 33
speech balloon icon, 82
startup screen, xiv
subfolders, 3. *See also* folders
system requirements, xii

T

Tag Options dialog box, 39
tags, 38–54
 Alphabetical Order option
 for, 39
 attaching to photos/folders,
 41–43
 changing appearance of icon
 for, 49–50
 changing category for, 51–52
 changing display size for, 39
 collapsing/expanding, 53
 creating, 40
 creating categories for, 46–47
 deleting, 54
 finding photos by, 74–77
 folder-based, 44
 hiding/showing, 26
 including with emailed
 photos, 142
 naming/renaming, 40, 48
 organizing, 46–54
 purpose of, 23, 38
 removing from photos, 45
 use of special characters
 in, 51
 vs. other organization
 tools, 23

Tags pane. *See also* tags
 changing view for, 39
 collapsing/expanding
 categories in, 53
 creating new tags in, 40
 finding photos by tag in, 74–76
 hiding/showing, 38
 location of, xii
 purpose of, 38
Tags toolbar, 40, 46, 48, 51, 54
Tags view, 29
templates, project, 113, 124
thumbnail images, 17, 24, 39
thumbnail references, 16
TIFF format, 8, 154
time
 changing photo's, 36–37
 finding photos with
 unknown, 82
 hiding/showing, 26
 and photo source, 37
time zones, 37
timeline
 adjusting date range for, 79
 displaying, 78
 finding photos with, xviii,
 73–78, 79
 and hidden photos, 76
 for new catalog, 70
titles
 bound photo book, 126
 eCard, 122
 fonts used for, 113
 greeting card, 120
 photo album
 photo calendar, 124
 slideshow, 116
TiVo, xii, 146
Transfer Images dialog box, 5
transitions, slideshow, 117, 118
trash icon, 54
TWAIN, 3, 4, 5–6, 9

U

Undo Auto Fix command, 99
Undo button, 92
Undo Delete Tag(s) command, 54
Untagged Items command, 75
updates, program, xxvi
upgrading program, xiv, xv
USB ports, xii, 2, 3, 8

V

Verify button, 65, 153
video CDs, 119, 150
video clips, 28
views
 illustrations of, 29
 returning to previous, xx
 switching among, xix–xx
Visual QuickStart Guides, xxiv

W

wallpaper, desktop, 133
Web sites
 Adobe, xxvi, 144, 146
 Digital Photography
 Review, 132
 sharing photos via, 147–149
 this book's companion, xxvi
white point, 96
WIA, 3
Windows, Microsoft, xii, 3, 95
Windows Image Acquisition, 3
write speed, 153

X

X icon, 28

Z

zoom controls, 24, 50, 89, 90, 93

INDEX